Lone Soldiers

Israel's Defenders from Around the World

by

Herb Keinon

Developed by **Lisa Hackel**
Photographs by **Ricki Rosen**

DEVORA
PUBLISHING
NEW YORK◆JERUSALEM◆LONDON

Lone Soldiers

Israel's Defenders from Around the World

Published by DEVORA PUBLISHING COMPANY

Written by	**Herb Keinon**
Text Copyright © 2009 by	**Lisa Hackel**
Photography:	**Ricki Rosen**
Cover and Book Design:	**Benjie Herskowitz**
Editorial and Production Director:	**Daniella Barak**

On the Cover: *Tzvika Levy celebrates with lone soldiers at their swearing-in ceremony at the Western Wall.* Photograph: Ricki Rosen

ISBN: 978-1-934440-60-5

Email: sales@devorapublishing.com
Web Site: www.devorapublishing.com

Printed in Israel

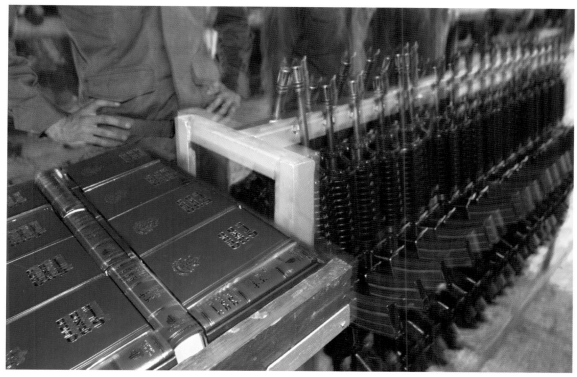

Soldiers receive their personal gun and Bible at an induction ceremony at the Western Wall.

For all of the lone soldiers – *hayalim bodedim* –
who have fallen in defense of the State of Israel

Table of Contents

Author's Note

Life is like a newspaper, I like to tell my four children, leaning on nearly twenty-five years of journalistic experience. It has different sections, and when you arrive at different stages of your life, you reach out and grab different segments of the paper.

For instance, as a boy, I'd grab the sports section – that's where my head was at, that's what interested me. In high school it would be the entertainment section, with an emphasis on the television schedule. I would completely pass over the international news section, until I went to college, started studying political science and needed to know about what was happening in, say, Taiwan.

As a single person I took no interest in education news. Since I didn't have any children, why should I care about budgeting for high schools? Until I married, moved to Israel, started having children of my own, and began taking an interest in stories about a shortage of certified pre-school teachers in Jerusalem.

And, up until a few years ago, my eyes just glanced over articles about the military. Granted, as the diplomatic correspondent for *The Jerusalem Post,* I had to be aware of the "big picture," but the "small" news stories – about the individual soldiers, the types of weapons being used, reports of hazing in certain units, which units were involved in what operations – those stories didn't interest me.

Until my oldest son graduated from high school and was beginning his pre-army preparations. Then I started reading those articles voraciously. I learned about the different units, finally figured out the military ranks, kept abreast of the terminology, and became fascinated by the new-fangled weaponry. All of a sudden it all became very immediate; very real.

That's the way life works – we are most interested in what immediately affects us.

It was in that spirit that I felt fortunate to have the opportunity to write a book about lone soldiers in the Israeli army, young men and women from the Diaspora who come to serve in the IDF. Not because I have a lone soldier son, but because I have a soldier son, and the experiences – while very different in some respects – are also very similar in others.

When one of the soldiers interviewed for this book talked about the physical difficulty of the tryouts for one of the army's elite units, I could identify, because my son – who went through that very same tryout – told me the same thing.

When another lone soldier talked about what it was like going to the induction center, and seeing all the parents send their kids off, while he stood there alone, I could identify, because I was one of those parents.

And when a third soldier talked about the fear his parents obviously felt when he was fighting in southern Lebanon, I could identify, because my wife and I were gripped by that same take-your-breath-away anxiety when our son was fighting in the Gaza Strip.

As a result of my son's experiences, I was able to appreciate more what the lone soldiers were going through. First of all, because I could relate to it. And secondly, because if it was difficult for my normative Israeli son – and he had been preparing for and thinking about the army for years, and had full societal and family support and guidance every step of the way – then how much more difficult must it be for those who didn't have that guidance, support, or preparation.

Coincidentally, Lisa Hackel – the driving force behind this book – contacted me about writing *Lone Soldiers: Israel's Defenders from Around the World* about six months before my son was to be inducted. The timing was fortuitous, and the writing almost cathartic. By interviewing people who were talking in much the same way as my son was talking, by writing about soldiers who were going through experiences similar to those of my son, I was better able to understand both the subjects of my interviews and my son; a symbiosis that led to an enhanced appreciation and respect for both.

As a result, I'm grateful for having had the opportunity to write this book. I'm also thankful to my wife, Susie, who was fully supportive and encouraging, as were my kids: Yona, Malka, Rafael, and Yair.

Herb Keinon

Foreword

by **Ehud Barak**

This special book, written by Herb Keinon, tells the wonderful tale of fourteen lone soldiers in the Israeli Defense Forces, and the heart-warming story of a unique man, Tzvika Levy, from Kibbutz Yifat. Tzvika, who is known as the "father of the lone soldiers," has dedicated two decades of his life to youth whose hearts have led them from distant lands to the ranks of the IDF– even though they arrive without the support of family or friends in Israel.

The phenomenon of lone soldiers in the IDF is a moving one. Most of them come to Israel alone and leave behind a home, friends, an orderly life, and familiar surroundings to join themselves to the lofty goal of defending the State of Israel. They know when they set out that a rose garden does not await them, but they are ready. In fact, if they are healthy and in good shape they prefer the very demanding path of being combat soldiers, and choose to be at the front in combat with the enemy. Their decision to follow their consciences and cross oceans and continents to come to Israel is proof alone of the strength and power of their character.

They are not deterred by any difficulty, and have a spirit of steel, something they prove by the way they perform as soldiers and fighters on missions that demand courage, resourcefulness, and sacrifice – and which often place them in life-threatening situations.

The importance and contribution of the lone soldiers to the State of Israel and the IDF is immeasurable. In an era of materialism and hedonism, of evading responsibility and service, of prostration to the gods of celebrity and money, of the pursuit of immediate gratification and the easy life – they represent the opposite pole. Every lone soldier is an example that inspires. They reinforce the healthy tendencies that fortunately still live within the midst of most of Israel's youth, and which are manifest in a desire to serve in elite voluntary units. The personal example shown by the lone soldiers, who come from afar and volunteer to serve of their own free will out of pure Zionist ideals, is an educational value of the first degree.

However, volunteering and giving to a worthy and important cause is obviously never a one-way street. The recompense to the lone soldiers for serving in the IDF is a feeling of tremendous satisfaction, self-actualization, achieving a goal, and molding their characters under physical and emotional tests. The experience of serving in the IDF, especially in the combat

units, is a defining experience that provides internal maturity and self-confidence that are true assets for life.

Moreover, the characterization "lone soldier" to a large extent misses the mark. Even if these soldiers are cut off from the warmth of their family homes, the IDF gives them a family-like framework, friends, and comrades-in-arms whose friendship is forged in the tents and barracks, during navigation in the desert, and in the line of fire. These friendships remain forever.

This book presents fourteen stories that typify thousands of Jewish youth from all across the world whose love of and commitment to Israel outweigh all other considerations, including often the fierce opposition of their parents, families, and friends. Many of the lone soldiers have paid the personal price of postponing studies and careers, have diverted from their comfortable and protected life path, and have distanced themselves from friends and loved ones. But the goal is holy in their eyes, and they go toward it without looking back. They have proven to themselves and us that Zionism is not an archaic concept, but rather a living and beating ideal that calls – as in the past – to youth to rally around. One of the book's moving chapters is dedicated to St.-Sgt. Michael Levin, of blessed memory, a beloved and excellent lone soldier who hurried back to Israel from a vacation with his family in the US during the Second Lebanon War, and then fell in battle.

Tzvika Levy, and other volunteers like him, are the flip side of the same coin. Tzvika, to whom a chapter is dedicated, embodies the face of "beautiful Israel," as well as of the kibbutz movement in all its glory and splendor. Thanks to his energetic efforts, half of the kibbutzim in Israel have adopted close to 750 lone soldiers, and they are not done yet. Each of these soldiers gets a room on the kibbutz, an adoptive family, and the benefits the kibbutzim give to all their soldiers. That is Zionism in the true sense of the word.

Herb Keinon's book is a testimony to the love of Israel and to the unity and cooperation between Jews in Israel and the Diaspora. I am sure this book will cause a stir among Jewish youth abroad and give inspiration and a push to a large number of youth to come and put their shoulders behind the biggest challenge facing the Jewish people in our time: fortifying the existence, and strengthening the security, of the State of Israel.

Defense Minister
January 2009

Preface

The idea for *Lone Soldiers: Israel's Defenders from Around the World* was born in December 2005 during a trip to Israel with my husband, Ken, and two sons – Adam, age thirteen, and Brian, age eleven. Our older son was determined to sponsor a shwarma party for soldiers at an army base as part of his bar mitzvah project. The party turned into the donation of a much-needed item, a television, but that's a whole other story. In the midst of a very complicated process to gain access to a base (facilitated by Naomi Eisenberger at the Ziv Tzedakah Fund), we encountered Lt.-Col. (res.) Tzvika Levy, who made the experience possible. It was an amazing day for the four of us, who were forever touched by the appreciation that these young combat soldiers of Golani's 13th Battalion expressed – not just for the gift, but for the support of Americans for what they were doing every day to protect Israel's northern border.

But who was Tzvika Levy?

When we returned I learned more from Naomi about his work. He had a long and distinguished military career, which was remarkable in itself. The part of his story that was particularly captivating, though, was the work that he had done for so many years on behalf of lone soldiers. I have to admit, despite spending substantial time in Israel, it was the first time I heard the term "lone soldiers." I certainly knew there were some Americans who joined the IDF, but had no idea that there were so many (several thousand at a time) young men and women from all around the world who leave their homelands and families to defend the State of Israel. As the founder and director of the IDF Lone Soldier Program for the Kibbutz Movement, Tzvika has eased the path of these young people – both through emotional support as well as providing material needs. I learned why he is often referred to as the "father of the lone soldiers."

At the same time that Tzvika's story was so compelling, I also wanted to find out more about these "lone soldiers." What were their motivations? Were they ardent Zionists? Were there other reasons they wanted to be in the Israeli army? What was it like doing often dangerous work without the support of families nearby? Before I knew the answers to these questions, I was convinced that the story was an important one. And so the decision to create a book was made.

Through a fortuitous event, I was able to reconnect with an old friend from Denver, Herb Keinon, who made aliya in 1981, soon after we were both on a junior year abroad program at

the Hebrew University. A long-time journalist for *The Jerusalem Post*, he came to my synagogue in New York to speak about the current political situation in Israel right around the time that I was formulating the idea for this book. Maybe coincidence – maybe *beshert* – he later agreed to take on this unusual venture as the writer. After following Tzvika around the country to understand his story, Herb traveled from one part of Israel to the next to interview each lone soldier in the book. Beyond his journalistic skills, he also brings his strong sense of humanity to each soldier's story. I am forever grateful for his dedication and cannot imagine how the book would have become a reality without his participation.

Ricki Rosen brought her sensitive photojournalistic eye to the project and was able to bring out the unique qualities in the young men and women whose stories were told. She also captured the many facets of Tzvika's life and work. I greatly appreciate her persistence in navigating the complicated logistics of photographing soldiers on active duty.

I want to thank the army censor for reviewing and approving the manuscript. In addition, the IDF Spokesperson's Office helped facilitate taking pictures of the soldiers.

I want to acknowledge Naomi Eisenberger, currently managing director of the Good People Fund, who helped connect us with Tzvika Levy and who works tirelessly to promote tzedakah projects both here and in Israel. A special thank-you goes to Roni Rubenstein, a passionate advocate in the US for Tzvika Levy's work, who helped bring his story and the story of the lone soldiers to life for me.

I am deeply grateful to Harriet and Mark Levin for sharing the story of their son Michael, a lone soldier from Philadelphia who was killed in the Second Lebanon War in the summer of 2006. His inspiring story has brought tremendous attention to all of the lone soldiers who have a unique role in defending the State of Israel.

Now that I have the answers to some of my original questions about Israel's lone soldiers, I know that this is not just a story about Zionism, but also one about sacrifice, courage, sometimes pure adventure, and following one's beliefs.

Lisa Hackel

Introduction

Few, really, are the activities that Israeli soldiers do alone. They train in companies, fight in battalions, go on missions in teams, patrol in pairs, sleep in bunk beds, and eat together at long tables. In that sense, the term "lone soldier" (*hayal boded*) is an oxymoron. For the most part, the Israeli soldier is – with the exception of guard duty – almost never alone, at least in a physical sense.

In an emotional sense, the normative Israeli soldier is also rarely alone. It takes a family and community to see a soldier into and through his tour of duty (three years for men, two years for women). The Israeli kid does not, on his eighteenth birthday, just bounce out of bed one morning and say, "I'm ready to join the IDF and fight its wars, track down its enemies, put my life on the line."

It's a process, a long socialization process that starts at home, and runs through schools, youth groups, and peers. By the time the soldier is ready to don the uniform, he or she has thought and talked ceaselessly about the army – about what unit to go into, what to expect, how to prepare. Israeli high-school kids fixate about the army in the tenth, eleventh, and twelfth grades to the same degree that high-school youth in the US become preoccupied about applying and then going to college.

When, indeed, induction time finally rolls around, the soldier's family plays a huge supporting role. The parents take their kids to the induction point, visit the basic training base, are visited at home by their child's officer, go to various "graduation" ceremonies, travel to their kid's base on holidays if their sons or daughters have to "stay in." They shop, cook, run errands, and wash their children's clothes when they come home for Shabbat and holidays.

And, because Israel is such a small country, the Israeli soldiers get home more than soldiers in most other armies in the world. It is not unusual for the IDF soldier to get home every other Shabbat, sometimes even every Shabbat. To go twenty-eight straight days in the IDF without getting home is – except for those serving at sea – extremely rare, and viewed by most soldiers as an almost unbearable situation.

This means many parents are privy to an almost blow-by-blow account of their kids' service: hearing complaints about officers, stories about comrades, talk about missions and operations. The parents listen, fret, and give advice so that on the emotional plane, as well as the physical one, the Israeli soldiers are also not often alone.

Except those from abroad who volunteer to serve, and come here without families. Or those Israelis who have families, but are either estranged from them, or whose families are dysfunctional. These soldiers don't have that key familial support, and as such are classified by the army as "lone soldiers" (*hayalim bodedim*) – lone in the sense that they serve without a support system that the army itself recognizes as critical. In 2008 the number of lone soldiers stood at about 5,000, of whom some 4,000 were soldiers who came from dozens of countries around the globe.

Numerous individuals and organizations have, over the years, sprung up to fill in the gaps and give these soldiers family-like support – finding lone soldiers a place to live, buying them washing machines and microwave ovens, organizing special events for them away from the base on days when everyone else's parents come to visit, helping them navigate the country's bureaucratic maze, supplying care packages and gifts on holidays, and being available for advice.

One of those people is Lt.-Col. (res.) Tzvika Levy, the Defense Ministry's coordinator of the Lone Soldier Program for the Kibbutz Movement, who has been instrumental not only in providing material and emotional assistance to the lone soldiers for decades, but who has also been key in raising the profile of the lone soldiers both in the army and in the country.

Levy took notice of the lone soldiers and both their unique problems and potential more than two decades ago, before almost anyone else was paying attention. Before Levy became actively involved, the term "lone soldier" was familiar to the lone soldiers themselves and a few officers who dealt with giving them certain benefits; today it is a concept known to nearly everyone in the country. Tzvika is largely responsible for this change.

But Levy is not alone. Numerous others are involved, from Avigdor Kahalani, the chairman of Aguda Lema'an Hachayal – the Association for the Wellbeing of Israel's Soldiers; to the Friends of the Israel Defense Forces; to the Jewish Agency for Israel; to Barbara Silverman, a woman in Jerusalem who independently and tirelessly organizes and packs gift bags for soldiers; to the Heseg Foundation, which provides scholarships for study and living expenses to lone soldiers who want to study in Israel after their service; to Tziki Aud, who for years provided critical guidance and help at the Jewish Agency to the lone soldiers.

The lone soldier appellation is more than a name, it is also a status in the army – a status that grants the eligible soldier a higher monthly stipend, about double the small usual monthly salary for soldiers. It also gives the soldiers the right to a day off every month to run the errands that the regular soldiers don't have to cope with, an extra 30 days' furlough every year, and – for those in combat units – one free trip abroad to visit their families during their tour of duty. These are hard-fought-for benefits that attest to the importance the army and the state attach to these soldiers.

And the state does attach importance to those who leave family, friends, and familiarity to take up arms for a country whose language they often do not speak, whose customs they do not understand, and whose mindset takes some getting used to.

Since even before the creation of the state, young Jews from around the world have come to Israel and volunteered to help the country defend itself. In 1948 some 3,500 volunteers, like legendary Mickey Marcus who was killed in action and immortalized in the movie *Cast a Giant Shadow,* came from abroad within a framework called *Mitnadvei Chutz L'aretz* (Volunteers from Abroad) and played a decisive role in Israel's victory. Many of those were World War II veterans who had the training, skill, and discipline that were sorely lacking and needed in the nascent state's nascent army.

That volunteerism did not die when Israel was founded, and trickles of young Diaspora Jews continued to come to Israel over the years to serve. But now the soldiers from abroad bring with them not already acquired military skills or expertise, although that still happens at rare intervals, but rather fierce motivation. These soldiers are not in the IDF because they have to be – as is the case for most native-born Israelis – but because they want to be, and that makes a huge difference in terms of motivation.

The reasons the lone soldiers sign up are varied: Some are following what they believe is a religious imperative, others are providing their own answer to the Nazis. Some of the lone soldiers are looking for fun or glory, others are keen on leaving home countries where they feel opportunities are limited or anti-Semitism is rife, and still others are simply living out deeply-felt Zionist ideals. Most are following an internal stirring even they find difficult to identify or articulate, but which is surely one of those ingredients that have ensured Jewish survival: an almost mystical sense of commitment, attachment, and responsibility.

Some come, serve in the army, and return to the land of their birth. More than half stay and build lives in Israel. About thirty-five percent are female, one-third are religious, some 750 are placed on kibbutzim, and fully sixty percent serve in combat units, with a large number of those going into the country's elite reconnaissance units. A few – like American Michael Levin, Ukrainian Yonatan Vlasyuk, French Yoan Zarbiv, Ethiopian Yasmou Yalau and Australian Assaf Namar – have been killed in combat. Those five were killed in the Second Lebanon War in 2006.

Interestingly enough, the number of lone soldiers is on the rise: because the Birthright program exposes more and more college-age Diaspora youth to Israel; because of the large number of Israeli emigrants abroad who have kids who feel an obligation to serve; and because Palestinian terrorism, the Second Lebanon War, the rocket attacks from the Gaza Strip, and the Iranian threat have led to a sense among some Diaspora Jewish youth that Israel's existence cannot be taken for granted, and that they must get up and actively contribute to its defense.

The Israeli public has become increasingly interested in this whole phenomenon, both because the increase in lone soldiers means more and more Israeli soldiers have someone in their unit who fits into this category, and also because many Israelis were moved by the widely reported tales during the Second Lebanon War of lone soldiers who fell.

And along with the awareness has come curiosity. Who are these soldiers, and why do they do it?

This book tells the tale of fourteen of these soldiers. Who they are, what brought them to Israel, what motivates them, what their parents think, how they have been accepted, and what they have experienced in their adopted army. It also tells the story of Tzvika Levy, someone who embodies the values of "old-school" Israel, and is inextricably wrapped up with the lone soldiers.

Beyond actively defending the country, the lone soldiers serve Israel in two other capacities as well. First, their very presence in uniform is an important ideological counterbalance to the stories of some Israeli youth trying to dodge their military duty. And, secondly, they remind all Israelis – not just those who serve with them – that despite the country's problems, hardships, and challenges, Zionism is alive, kicking, and relevant; that the idea of the Jewish state still has the force and vigor to stir people in far reaches of the globe to action – difficult action, dangerous action, sacrificial action, but action that, for the Jewish people, genuinely makes a difference.

Lt.-Col. (res.) Tzvika Levy

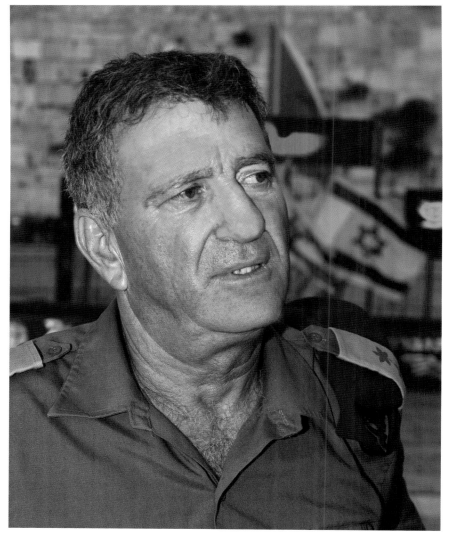

Levy at a paratrooper swearing-in ceremony at the Western Wall.

O n a gloomy mid-March day, about 120 Israeli soldiers shuffle into a poorly lit, gray-walled auditorium. They have just finished a two-week pre-basic training course for lone soldiers, and on the next day will attend tryouts for one of the IDF's prize units: the Paratroopers.

Of the 120 soldiers in the hall, all but a couple are newcomers from around the world. They are from Brazil and Ethiopia, from Russia, Turkmenistan, Ukraine, France, the United States, and numerous points in between. There are also a handful of native-born Israelis.

Of the group, about thirty will finish the tryout (called *gibush* in Hebrew) and be accepted into the Paratroopers, a unit identifiable in Israel by clay-red boots and crimson berets. The rest will end up in other units: Golani, Givati, Nahal, artillery, the armored division.

For native-born Israeli high-school kids, the gibush is something they hear about, discuss, prepare for, and fret about for years. It's for Israeli youth what the SAT college admission exams are for American kids – an object of constant adolescent obsession.

But the gibush, unlike the SATs, doesn't last for four hours and test math aptitude and vocabulary; rather it lasts – depending on the unit – between twenty-four hours and six days, and tests decision-making, teamwork, leadership skills, logic, and both physical stamina and conditioning. And the gibush, unlike the SATs, isn't a ticket to the school of one's choice, but rather the army unit of one's preference.

That's the case for the Israeli kids.

But most of those gathered in this auditorium on this wintry day at a large army base in the lower Galilee called Michveh Elon are not native-born Israelis. They didn't grow up in Tel Aviv, Haifa, and Beersheba, but rather in Toronto, Houston, and Buenos Aires. As a result, the gibush is not something they grew up on, or have heard about constantly from stories embellished by older brothers and cousins.

Most of those in this hall, dusty from the dirt on their black IDF boots, have been in the country for only a few months and can't even pronounce the word *gibush* properly. Their socialization process has been far different from that of the Israelis, and their home societies have not put them on a trajectory that prepares them – from about the ninth grade – for the three-year compulsory service in the Israeli army.

Yet on the next day these 120 males, slouching in plastic seats with pull-up desks, will be going through the gibush: trekking for kilometers carrying a stretcher laden with one of their comrades, standing for hours with sandbags on their backs, crawling through fields strewn with thorns, dropping for a hundred push-ups, eating lunch in seven minutes.

Most of them have little idea of what awaits them. And for that reason they are listening attentively to the words of Lt.-Col. (res.) Tzvika Levy.

Tzvika, fifty-eight, a clean-shaven, curly-haired, father of four and grandfather of three, makes the thirty-minute drive from his lower Galilee home on Kibbutz Yifat to this base in a white Subaru, with an "I'm a proud reservist" sticker and two paratrooper decals prominently placed on the back window. He walks into the base like he owns it, supremely confident. Passing a group of soldiers, he says, "Shalom, youngsters," and doesn't stop for even a second to hear the smart-aleck replies.

Wearing green pants, and a gray flannel shirt opened to show a blue T-shirt, Tzvika carries a certain swagger into the auditorium, where his audience is tired, now accustomed to officers talking tough, and edgy about what to expect the next day.

"When you get to the base tomorrow for the gibush, one of the first things they will do is have you run 2,000 meters," Tzvika says, his booming voice – unaugmented by a microphone – clearly audible in the back rows. "It's a personal test, not to see how fast you run, but what you do if somebody falls."

Tzvika drops to the floor and starts to do a few push-ups. "They will ask you to do a hundred push-ups," he shouts out between pants, as some chuckle at the spectacle of a man their fathers' age working out before their eyes.

"If I can do it, and I'm fifty-eight, then you can do it," he says, stopping – however – after only a couple of push-ups.

"But that's not the point, that's not what they are testing. They want to see if you are straight, trustworthy. If you do ninety-nine-and-a-third push-ups, and say that you did a hundred, you are not in, you will not be a paratrooper," he says.

"It's called honesty, trustworthiness, being straight. Some of you won't get in because physically you can't make it. Others because of other issues, like honesty. Remember, if you do ninety-nine and a little, but say you finished, you are not in – and believe me, there will be a lot of soldiers there monitoring to see exactly what you do, and how you behave."

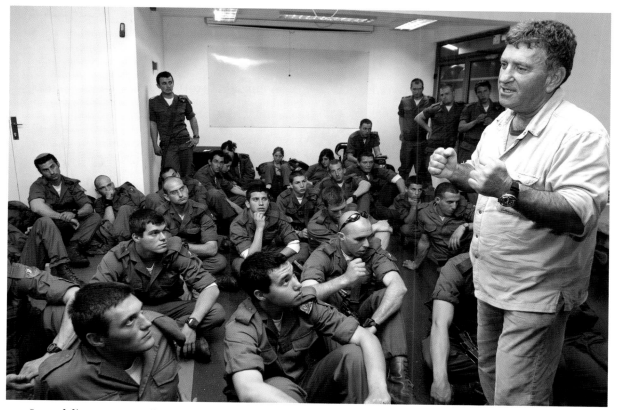

Levy delivers a pep talk to encourage lone soldier new recruits.

The hall is completely quiet; the audience hungry for some kind of indication of what awaits them the next day.

"They will get you up at four in the morning, and have you stand with sandbags, run with stretchers, crawl on thorns. But it will all be over by 1:30 in the afternoon. And that is important. That is very important, because everything that starts, finishes. Always remember that. Once things begin, the clock starts to run, starts to tick backwards. Keep that in mind, because everything is in the mind," he says.

This refrain, that everything is in the mind, is hammered into the minds of Israeli youth in school and in youth groups, and is meant to prepare them for life in combat units. But the new immigrants were not socialized in the same way. They need to hear this refrain; they need this advice, this counsel, before facing the army. Because the Zionist army they joined after leaving the comfort of their homes is hard, very hard – and Tzvika wants to make sure they realize that.

"I am a lone soldier," Tzvika says, play-acting for his audience, letting them know he understands where they are coming from, what is going through their minds.

"I saw a movie on Entebbe, I saw other movies, and I want to be Rambo," he says. "I come to Israel, get a gun and – boom – all of a sudden I'm in the army. But it's not Rambo. I am like everyone else. Like Jacques, like Itzik, like Sami, like Anton – like everyone. But I'm not Rambo – I don't kill the enemy every hour, I don't fly in planes.

"All of a sudden the dream – the ideal – blows up in my face. I'm in the army, but it's not what I thought."

Instead of living the life of Rambo, Tzvika tells the fresh-faced new recruits, they are in for officers who haze them and for periods of intense, utter loneliness.

In the best of circumstances, he says, the army is extremely difficult. But this difficulty is compounded for the lone soldier – the new immigrant who comes to Israel alone, without family, or the Israeli who comes from a dysfunctional family – because they don't have anyone to look after them.

The lone soldier doesn't have anybody to worry about him in the driving rain, or to remind him via an SMS message to drink a lot in the blistering heat. No one to serve as an advocate if need be, or to wash his clothes when he comes home for twenty-four hours, or cook a Shabbat meal. The lone soldier is alone in the country; and being both alone and in the army is a tall order.

"You're in basic training, and you fall asleep when an officer is talking," Tzvika says during his presentation, pointing to a soldier who nodded off during his speech.

"Igor," he yells in the direction of a Russian-looking recruit. "Wake up, don't fall asleep on me.

"There was a soldier once from the US named Michael," Tzvika says, repeating a story he often uses with various audiences to illustrate the frustrations and difficulties facing lone soldiers.

"He was in Givati, but didn't understand everything they told him. His Hebrew wasn't perfect. But he did everything. He ran up one hill and down another – everything they asked

him, he did. At one point he closed his eyes exactly at the moment when his officer looked in his direction."

"Michael, get up," Tzvika shouts, acting the role of the unsympathetic officer who caught Michael dozing off. "Michael didn't understand what was going on; he thought he was getting a citation for being such a good soldier, for running up and down the hills like he had been told.

"'Go outside and put a jerrycan on your back,' the sergeant shouted.

"He looked, and saw that no one else was doing this – but he went outside and put on the jerrycan. 'Run to the bathroom,' the officer yelled. 'But I don't need the bathroom,' Michael said. 'Run,' the officer yelled. The sergeant was cracking up, and Michael ran. He didn't understand; he thought he was getting a citation for being a good soldier."

The auditorium is uncomfortably silent. No one laughs or even chuckles at the story. Obviously not; most are thinking that the same thing could easily happen to them

"After an experience like that, you'll say, 'I don't want to come back to the army. It's not what I thought. I want to go back to Beverly Hills, to Brooklyn, to Paris or Buenos Aires. There I had a car, swimming pools, money, and friends. Here I have nothing – only a sergeant who makes fun of me.'"

And this, Tzvika says, is where the IDF reality collides with the ideal.

"You lie in your bed and your head will be turned inside out. You remember that your parents didn't want you to come to the army in the first place, that they don't give you money because you came to Israel, but you waved your hand at them and said 'I'm going to Israel, to the land of the Jews.' And now, when you're in bed, you think of your mother, and your father, and your sister, and your friends, and think, 'What the hell did I do? My officer doesn't look at me, I have no girlfriend, I go to Tel Aviv and no one knows me. Nothing.'"

And it is exactly into this void that Tzvika steps.

In the numerous Israeli newspaper clippings in which Tzvika appears – articles dealing with immigrant soldiers under headlines like "An eighty-three-degree change: from Alaska to Gaza" – his name is often followed by the appellation "father of the lone soldiers."

And this, indeed, is how Levy – who since 1995 has formally headed a project from the Kibbutz Movement to adopt lone soldiers – defines himself.

In 2001 Tzvika attended an induction ceremony for the Golani unit. The Israeli parents proudly watched their sons get a Bible and a gun –gear formally received upon entrance into the IDF – and afterward took them aside, gave them gifts of their own, and had a family barbecue: schnitzel, kebab, and hamburgers.

The lone soldiers stood to the side and watched.

"I went up to the commander, and said, 'Why don't you gather all the lone soldiers together,

slap them on the back and thank them for volunteering to serve in the army? Remember, they are not like you: they are volunteering, they don't have to do this.'

"'Tzvika, you are their advocate, you do it,' he told me. From that time on they invite me to every ceremony, and I come with schnitzels and presents for the lone soldiers. One soldier said at one of these occasions, 'You are like our father,' and since then that is how I've been known.'"

Israeli parents are actively involved in their kids' army service: from pulling strings to get their children into the units of their choice, to hearing the stories, to worrying endlessly, to buying supplemental equipment and sending care packages.

There are certain days when parents are invited to the various bases throughout the year. In addition, on every Friday and Shabbat a drive past the country's army bases – large "mother bases" with thousands of soldiers, or small outposts of less than a dozen – will find a smattering of cars parked outside, music blaring, smoke rising from a grill, and a soldier surrounded by a circle of family and friends.

This, says Tzvika, is the time when the lone soldier feels most alone.

"How do you think the lone soldier feels when he is at his induction ceremony, and at the end everyone throws their berets into the air, and then falls into the arms of their parents?

"The forty lone soldiers will look to their left, look to their right, and not see their mother or father. Maybe, maybe, Igor's girlfriend Svetlana will be there, or Jenya, or Jacqueline, Jacques's girlfriend from France.

"It is at those times that, while everyone else has parents here, they will be thinking about their mothers in Texas, or in Ethiopia, or in St Petersburg. This pinches my heart."

Tzvika now makes it a point to know in advance each time a unit has a parents' day. "I try to make sure that each unit lets the lone soldiers go for a day that I organize – a 'fun day' where I take them from the base. I take them outside – give them sweatshirts, socks, underwear, chocolates, and food. I take them to a place where there is a swimming pool, a massage. I try to give them something nice so that they say, 'Wow, there are people who care about us, who want things here to be good for us.'"

On a formal basis, Tzvika is the coordinator of the Lone Soldier Program for the Kibbutz Movement. He is responsible for placing some 750 soldiers on kibbutzim across the country. He finds them rooms, equips the rooms, sets the soldiers up with "adoptive" families, and follows their progress by visiting them regularly on their kibbutzim and in the army. In all this he is assisted tirelessly by Ayelet Godard, a woman on Kibbutz Be'eri in the south, about 10 minutes from the Gaza Strip, who volunteers her time.

But Tzvika's reputation has spread beyond those lone soldiers on kibbutzim, and he has become a veritable Wailing Wall for any lone soldier who needs help or intervention.

The calls are unending, with Tzvika fielding some 200 a day – from the soldiers themselves, their officers, Diaspora youth who want to join up, or from parents abroad.

"Today a father called from Los Angeles and asked if I would talk his son into going into the army," Tzvika says over a piece of cheesecake one afternoon in a Jerusalem coffee shop.

Lone soldiers enjoy a day of rest and relaxation organized by Levy.

The father said it was a shame that his son – who was studying in an intensive Hebrew-language course at Kibbutz Ma'agan Michael in the north of the country – was in Israel but not interested in the army.

Like so many other calls that come in on one of his three cellular phones, Tzvika at first had no idea how this father got to him.

"He told me that he called the consulate in LA, which gave him the number of someone in the army, who gave him my number. They told him to call Tzvika Levy, that he knows how to talk to kids like his.

"He called me at six-thirty in the morning. He said he left Israel in 1982 and went to open a business in LA. He asked me to go speak to his son, and convince him to go into Nahal, the unit he was in. He warned me to be careful, since his boy was sensitive.

"I will talk to the boy, but when I do I will tell him not to do the army for his father, but for himself. He has to want to do it. And then I will tell him that if that is indeed what he wants to do, he will not be alone. That I will be with him, from the beginning. Shoulder to shoulder. I don't say, 'Go to the army, and bye, I'll send you a postcard.' I will treat him like my own son, will be there with him at the induction ceremony, and all the way through."

The problems facing lone soldiers are not restricted to having no one to do their laundry or cook their meals when they get a short furlough, but rather that they also don't have anyone to intervene for them with the faceless and often uncaring army bureaucracy.

"When my son Dotan, who is an officer in the army, has a problem, he can come to me and say, 'Abba, help me. Abba, take care of it.' And this is the case with my neighbor's kid, or the kid of someone who lives in Tel Aviv or Jerusalem. But these kids don't have that, and it

is critically important," Tzvika says.

Just how important was illustrated in another phone call he received while sitting in the Jerusalem coffee shop.

"Tzvika," a heavily Russian-accented voice blared from the other side of the phone. "My name is Pavel, I am in the Paratroopers. I'm having problems with my conversion, and don't know where to turn."

Tzvika remembers the soldier; he met him once at an induction ceremony at the Western Wall, and goes on to hear his tale, hurriedly jotting down the details on a napkin-sized slip of paper. Pavel, like so many other Russian immigrants in the country, does not have a Jewish mother and for that reason is not halachically Jewish. He is in a special conversion course the army has set up, but has run into a problem with the whole process.

"Wait a second," Tzvika says, holding the cellphone to his left ear. He pulls another cellphone from his pocket, and in the automatic dial finds the number of the IDF head of manpower, Maj.-Gen. Elazar Stern.

"Hi, this is Tzvika Levy," he tells a secretary, calling one of the most senior officers in the IDF. "Is the head of manpower there, or Amir? I need to talk to them urgently about the conversion of a lone soldier." He is told they are currently unavailable.

But not thirty seconds later, while he is talking to Pavel on the other phone, Amir – Stern's chief assistant – calls back.

"Amir, hi, this is Tzvika Levy. Maybe you can help. I have an issue involving a fighter in the Paratroopers, someone who has been adopted by Kibbutz Gadot. He underwent conversion, but now they are giving him a hard time. They are complicating things for him, and I need Stern to intervene. I will give you his details tomorrow."

He hangs up, and goes back to Pavel, who heard the whole exchange on the other phone. "Did you hear, it will be taken care of on Sunday? Go, carry on being a good soldier. Shalom, brother."

Tzvika takes these types of requests to heart and deals with them immediately, because of a conviction that a soldier with acute personal problems cluttering his mind simply cannot be an effective fighter.

A few minutes later the phone rings again. A different type of problem, a different type of request altogether.

This call is from a woman on Kibbutz Ginossar, inquiring about the fate of a lone soldier she adopted named Yigal, originally from Belgium.

The boy, a soldier in Golani, flew with the army's permission to Belgium a few weeks earlier because his grandfather was sick. He returned to Israel, but then soon after received a call that his grandfather had died.

It was a Friday, and Yigal couldn't get in touch with his officer. So on his own volition he left his base, caught a plane and went to his grandfather's funeral in Antwerp. He was now afraid that when he came back to Israel the military police would consider him AWOL and put him in jail.

Tzvika spoke to Yigal's commanding officer, but says that the young officer saw things in black-and-white terms and wanted to punish the soldier. "If they send him to jail for this, what will he think for the rest of his life: that some officer, younger then he, put him in jail because he went to his grandfather's funeral? That's crazy."

So Tzvika called the commander's superior and explained the situation, pleading with the officer, a man he knows well, to keep the soldier out of jail.

"You have to make sure he doesn't go to jail," Tzvika urges. "Yell at him, keep him on the base for a couple of weeks, keep him there for Shabbat. But not to jail, that would cause me a lot of problems with the Jewish community in Belgium for a long time."

There are currently fifteen soldiers from Belgium serving in the IDF, all of them in combat units. The process is simple: one serves in the army, tells his friends back home about the experience, and they then follow in his footsteps. If it gets around that a Belgian soldier was sent to jail for merely flying to attend his grandfather's funeral, then others from Belgium will simply have no desire to serve, Tzvika explains, saying that the calculus is easy.

"The lone soldiers are like my kids, my sons," he says. "I try to look at them that way – not with my nose in the air, but at eye level. I try to understand what it is to walk in their shoes, to swim in their pool. Only that way can I understand them."

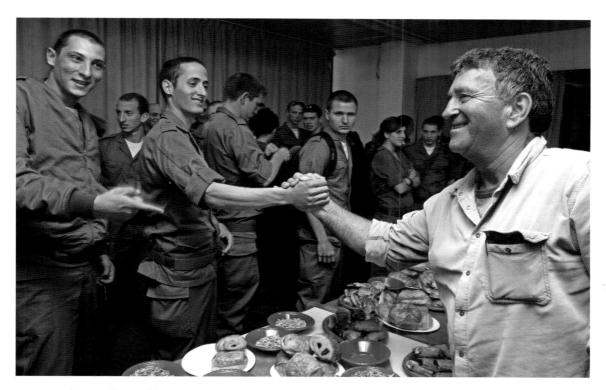

Levy welcomes lone soldiers to a day off from basic training.

Levy's interest in needy soldiers is rooted in a reserve duty stint he did immediately after the 1973 Yom Kippur War, when he saw fellow soldiers walking around the garbage cans on his base picking up discarded food to take home: cans of tuna, K-rations, even loaves of bread.

"Another reservist, somebody from my unit, came up to me and said, 'Tzvika, you live in a kibbutz, you have everything you need. We don't – we don't have anything at home.'

"These were guys from tough neighborhoods all around the country. I told him to bring me their names and addresses. There were thirty-three of them. I was dumbfounded. Here were soldiers, fighters, and paratroopers, without food at home. I told them to leave it; I would provide them with food.

"I took their address, and every Friday supplied them with packages of food. I got it from my friends, from kibbutzim, from caterers who had food left over, also from the army: tuna, olives, margarine, oil, sugar, two loaves of bread."

That was in the '70s. In the '80s, after that decade's war – the First Lebanon War – Tzvika became aware of another problem.

"When we exited Lebanon in 1982, there was a huge gathering of soldiers near Kiryat Shmona. Hundreds of soldiers. One group of soldiers stood off to the side, and I went up to them and asked who they were. We started talking, and they told me they were new immigrants. I wasn't aware of such a thing, didn't yet know about immigrant soldiers, and hadn't encountered anybody like that in my unit. I asked them where they lived, and if anybody was helping them out. I took their phone numbers, and would call them from time to time to ask if they needed anything – food, bedding. I just kind of started helping them out on my own."

His dedication to this particular cause was cemented two years later, again while serving in the reserves.

"It was twenty-three years ago in Gaza. I got a call at 5 AM – right before a huge maneuver inside Gaza. I was told my daughter Ofri had died. Crib death."

Tzvika talks about this incident calmly, very matter-of-factly. He has obviously told the tale innumerable times. It doesn't seem to faze him in the telling. This personal tragedy has motivated his work of the last two decades, and it features prominently in a television documentary on him produced in 2005. At a lecture in March 2007 at Kibbutz Be'eri, it also becomes clear that this heartbreak still has a grip on him.

Tzvika screens his documentary for a group of about forty kibbutz members who have come to hear him lecture. He explains his work, then shows the film.

As the film is being shown, Tzvika interjects various comments about the people involved – where they are now, what happened to them. At one point the film shows him going up to his child's grave at his own kibbutz, and gently placing a cotton blossom on the girl's small grave. Tzvika can't watch the scene. He turns his back, bites his lip, and only after the scene is over turns around to talk to the group.

It was not only Ofri's death, but also its immediate aftermath that left a huge impression

on Levy. "I was enveloped then by the love of the army," he explains.

"My commander drove me home immediately after I got the news, and then the army never left me alone. They surrounded me. Raful [then chief of staff Rafael Eitan] showed up at my house during the mourning period. He didn't tell me, or anyone else, that he was coming, and just showed up. He was out of uniform. The army was tremendous to me during this period, and I vowed then that I would give something back.

"Raful told me not to be immersed in my sadness," Tzvika recalls. "He told me that he had also lost a son, and said to take the sadness and do something positive with it. 'You love the soldiers, connect with them – adopt them,' he told me. He said to help the immigrants and the soldiers without parents who have no one to look after them. He said the army overlooks them. From that time I started to take home new immigrant soldiers – Russians, Ethiopians, Hungarians, Americans – whoever was there to take home."

Tzvika internalized something else that Eitan told him, and indeed has turned it into his own personal trademark, not to put flowers on graves, because the flowers wilt; but rather to place a small cotton blossom. The cotton doesn't wither, and its white reflects purity.

The experience also had another effect on Levy – it connected him with loss, with death, something Tzvika has seen much of during his forty years in the army. Indeed, he says that the names of literally dozens of people he knew – soldiers he fought with, who served in his unit – run through his mind every time he steps into the synagogue on his kibbutz: a synagogue he established on his secular kibbutz primarily to have a place to remember the fallen.

"When I go to synagogue on the memorial days [Yizkor], I go with a list. Not a written list, but one in my head. After I say the names of my parents, I go through all the soldiers that I have known. And when I do, it is like a video in my mind."

"How many people are on the list?" he is asked.

"Many," he says somberly.

"More than twenty?"

"Many more."

Then he begins to reel off battles he was involved in, and the numbers of dead.

There were twenty-two soldiers in his unit killed during the Six Day War in Gaza; fourteen in a patrol made up of twenty-six people ambushed near the Suez Canal during the War of Attrition in 1969; nine members of his unit killed in the Second Lebanon War.

And that is an incomplete list. It doesn't include those killed by terrorists.

Among the most heart-wrenching terror-victim stories is that of Julie Weiner, a twenty-one-year-old lone soldier killed in February 2001, in the early days of the outbreak of the second Palestinian intifada, when a terrorist plowed a car into a group of soldiers and civilians waiting at a bus stop near Holon, south of Tel Aviv.

Tzvika had taken Weiner, an immigrant from France, under his wing after she made aliya, and on that particular morning she was on her way to a training base in Rishon Letzion for a course that would make her an officer in the air force.

On her way to the course she called Tzvika, who was driving in his car. She said she was nervous, and asked his help in remembering the words to *Hatikvah*, the country's national anthem, thinking that she would be asked to sing it at the course. Tzvika sang *Hatikvah* with her that morning on the cellular phone.

"Five minutes later I heard on the radio that there was a terrorist attack," Tzvika remembers. "I knew she was in the area, and just knew something had happened." He immediately called her cellphone again, but there was no answer. Eight hours later his fears were confirmed – she was among the eight people killed in that attack.

As chilling as that was, the death that left the most searing impact on Tzvika was that of a close high-school friend, Ari Agasi, killed a few feet from Tzvika while they were on a patrol in the Jordan Valley in 1969, just before Tzvika was to be released from his compulsory army service.

"We were chasing fedayeen [infiltrators] in the Jordan Valley. It was terribly hot, 102 degrees. There were four of us in the jeep – an officer, tracker, Ari, and myself. The tracker said that he spotted some footprints, and within thirty seconds they opened fire," Tzvika recalls, dryly telling the tale.

"He was killed on the spot. I ran to the side, fired back, and killed two of them. I vowed then never to talk about this, and only spoke about it for the first time three years ago. To see a friend, a classmate, dead, with everything spilling out of him... I pulled him out afterward, carried him. It was very painful, I was in total shock."

Tzvika never went to visit the family of his friend, and even kept exactly what happened – what he saw, what he did – from his own wife. "She always told me, 'You have something inside, something that you are not letting out.' I told her she was right."

The story came out only three decades later while a producer on Kibbutz Yifat was filming a Memorial Day documentary. Agasi's parents had long since passed away, but Tzvika finally mustered the courage to go to one of Agasi's sisters. "I entered her house and she immediately broke down crying. She knew why I had come, what I had come to talk about.

"Ari helped me through basic training. He had tremendous strength, tremendous. He was a soccer player, and helped push me through the runs and hikes in the unit. When we became fighters I told him that I needed to help him, just once. He never let me. Only after his death, when I pulled his body out, was I able to help him."

But there was something inside – some kind of block – that kept Tzvika from trying to comfort Agasi's parents, his family. He couldn't do it. Perhaps as atonement, he has since taken it upon himself to comfort the families of other soldiers who have fallen.

An organization for fallen paratroopers was set up in 1973, which Tzvika became heavily involved in. It provides the children of fallen soldiers with camps in the summer and during the holidays, and gives them presents on their birthdays. "Whenever someone from the Paratroops falls, I go to the family, go to the grave, place a cotton blossom on the stone. Even people I don't know."

Tzvika became intensely involved in dealing with bereaved families following the Lebanon War in 1982, and there are parents of soldiers from that war with whom he has remained in contact to this day. "I call them on Friday, to say 'hello,' to let them know that they have not been forgotten." The Second Lebanon War in 2006 added seventeen widows, and twenty-one children, to the list.

In addition to feeling a special connection to the fallen of the Paratroopers, he also feels a link to the fallen of the Israel Security Agency, the Shin Bet. His connection to the Paratroopers is easily explainable because he was in that unit; his link to the Shin Bet has to do with his father, who was in its pre-state precursor – Shai.

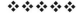

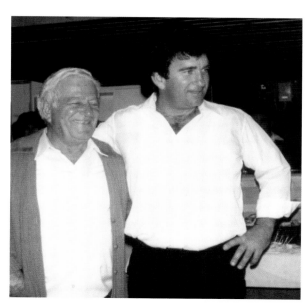

Levy with his father, Binyamin

Levy's father, Binyamin, figures prominently in Tzvika's talks with the lone soldiers.

"Welcome to Israel," he booms with a smile to the gathering of pre-gibush soldiers in Michveh Elon. "Those who came here this year, or last year. My father, of blessed memory, made aliya eighty years ago. He came from the Caucasus in Russia – there was no state. No roads, some tents, a lot of swamps, water, lots of diseases.

"Just like you, my father said he was going to Eretz Yisrael because that is our home, and because we have no other land. He was no older then nine. He came with his mother and three siblings. His father first came, but then went back to Russia. He did not stay – he was a communist."

This comment elicits chuckles from the large contingent of Russian-speaking soldiers in the hall.

"What you are doing now reminds me of what my father did then," Tzvika tells the soldiers.

Well, yes – in that Levy's father left familiar surroundings for an unknown land; and no – Israel of 2006 is light years removed from the Palestine his father arrived at in 1922.

Levy's father traveled to the country by camel, donkey, and on foot because his mother was a Zionist, and because she yearned to live in a Jewish land. When the family arrived in Mandatory Palestine they lived in a tiny apartment in the mixed Arab-Jewish town of Jaffa.

Soon afterward Binyamin's mother died, and since his father had returned to Russia, he was left in charge.

Binyamin Levy's story is the classic tale of the pre-state story of struggle and survival, of the early Zionists who endured hardship after hardship to remain in the country. He went to school for a while, then worked in Jaffa, picking up Arabic along the way. After his mother died, he couldn't take care of his younger sister, and took her to a church in Jaffa. She was then sent to a monastery in Jerusalem, and was reunited with the family only years later.

Binyamin's Arabic served him well, and he ended up working in the pre-state intelligence gathering apparatus of the Hagana called Shai, the precursor of today's Israel Security Agency, the country's secret service apparatus.

"For a couple of years he lived as an Arab shepherd in Jericho," Tzvika remembers. "He provided information on where the Arabs were manufacturing arms. He had to leave when the person whose house he was living in wanted him to marry his daughter."

During the War of Independence, Binyamin was stationed in Egypt, from where he smuggled in arms. According to Tzvika, he smuggled the first Tommy gun into the country. While he also worked in the unit after the war, the information Tzvika has of what exactly his father did is sparse, because his father was prohibited from talking about it.

It was during a security-related course at Kibbutz Beit Oren near Haifa, that Binyamin met Tzvika's mother, a woman who came from Russia in 1936, and whose entire family, with the exception of one brother, was wiped out in the Holocaust. They married and went to live on Kibbutz Gvat, one of the early kibbutzim in the Jezreel Valley.

That was the kibbutz movement's heyday, when the kibbutz members were society's ideological elites, and when the communal farms played a critical strategic role in firming up the country's borders, establishing necessary facts on the ground. It was also a time of intense ideological debate within the kibbutz movement, debates over the character of the kibbutz and the country itself, and this debate led to a split within Kibbutz Gvat, and the establishment in 1954 of Kibbutz Yifat, just down the road.

"I remember the split," says Tzvika, who was just six at the time. "We walked from Gvat to Yifat. I asked my father how I would know where our house would be. He said that he would plant a tree, and our house would be there. He planted the first tree on the kibbutz."

Beyond ideology, Kibbutz Yifat was established for security reasons – it sits on one side of the main road to the town of Afula, a road that in the early days of the state was a target for Arab marauders. A grove of trees, near Levy's house on Kibbutz Yifat today, was planted in commemoration of a soldier who fell on that road.

Tzvika grew up on the kibbutz – raised in a communal children's house – and went to the regional high school there. More than anything that he learned in high school, Tzvika remembers his experiences as a youth counselor during this period in nearby Migdal Ha'Emek, at the time a largely economically underdeveloped town populated mainly by Sephardim.

"I walked the kilometer there three times a week, for four years. I led activities, helped

kids with their homework. On Fridays we welcomed the Sabbath, I loved it."

He loved it, but his studies suffered as a result. At the end of the eleventh grade his teachers called in his parents and told them his grades were suffering, and he should give up the counseling.

"My mother told the teacher that she would talk to me, and get me to stop. But my father said, 'No, let his studies suffer, but let him do this. It's more important.' That taught me a valuable lesson."

Tzvika grew up in an environment where his parents "adopted" kids from tough homes in disadvantaged parts of the country, letting them live on the kibbutz, and looking after them emotionally. Tzvika internalized this, and today has similarly "adopted" some six kids on the kibbutz.

"My parents instilled in me something simple: that I have everything, and as a result of that, that I have what to give. We always had guests in our home – not for a week, but for years. One kid who had asthma came to live on the kibbutz for six years."

His father also instilled in him a feeling for the army, and when the time came for him to enter he knew – as a kibbutz kid – that there was only one real choice: the Paratroopers.

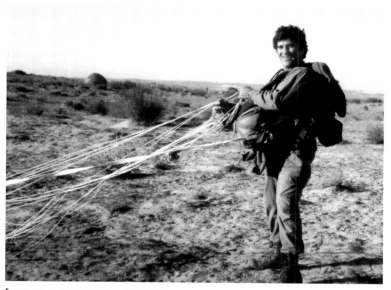

Levy as a young paratrooper

Tzvika was mobilized in late 1966, and within a few months found himself in the midst of the Six Day War with the Paratroopers unit, the 202nd Battalion, that captured Gaza. He has two strong recollections of that period: that two comrades were killed by a mine when they

crossed over into the Strip, and that his unit had to carry wounded comrades out of Gaza by foot on a stretcher to a nearby kibbutz from where they were then flown to a hospital.

During that period he also saw his father, dressed as an Arab, in Gaza City – something they never spoke about, but which was made public some twenty years later on a local television show in the Jezreel Valley that featured his father on his seventieth birthday.

"During the Six Day War I was in basic training," Tzvika remembers. "A week before my father came to meet me where my unit was, to bring me some clean underwear – he knew I wasn't going to be home for a while. I was in a hurry, so all he said was 'shalom,' 'take care of yourself,' and 'good-bye.'

"A month later, after we captured an outpost overlooking Gaza, we went into the city. In one of the alleys I saw someone and said to myself, 'that's weird, he looks familiar.' I recognized the eyes, and the way he walked, but I didn't believe what I saw, put it somewhere deep inside of me, and moved on. A month later when I went home and my father and I talked about our experiences in the war, no one mentioned this.

"Some twenty years later, when they did the program on my father, they brought me to the stage, and I said, 'Abba, there is something I need to ask you, during the Six Day War...' And then, without waiting to hear the question, he cut in, and cut me off, and said, 'It was me.'

"That was the end of the story. I saw him that day in Gaza, he saw me, and we were both smart enough not to talk about it. My father never talked about what he did in the security services, and we never asked."

After capturing Gaza within a few days, Tzvika's unit was flown to the Golan Heights, where it took part in the last day and a half of fighting there at Kibbutz Afik. When that fighting ended, it was back to Gaza, where the unit remained for an additional three months.

Tzvika was released from compulsory duty in 1969, two weeks after a patrol he was on was ambushed in the Suez Canal during the War of Attrition, killing fourteen soldiers. He was one of twelve survivors. "I went through some difficult days then," he says laconically, looking at his weathered hands, not elaborating.

After his discharge from the army, Levy returned to the kibbutz of his youth, worked in the Jezreel Valley cotton fields and continued to do youth group work.

He then did what so many young Israelis do after serving in the army – he went abroad for three months, traveling in Europe – and then returned and married Naomi, whom he described as a "beautiful" woman some six years his junior, who had just finished her compulsory service and was living on Yifat.

"She was from Tivon, and came to the kibbutz school as an outside student. She had a boyfriend, but we connected. She is the opposite of me – quiet, calm, reserved, relaxed. She complements me."

The wedding took place in February 1974, the tense period immediately after the Yom Kippur War.

"I was at the Suez Canal during the war, spent about a hundred days there. We shot, we

killed, we won. I remember that we received a bottle of wine from Arik Sharon [who commanded the units there] because we knocked out a snipers' nest with missiles we received from the US.

"I remember Arik coming to my outpost, and saying, 'Where is Tzvika Levy, Binyamin's son?' He knew my father from the pre-state days. He came up, gave us a bottle of champagne, and complimented us for knocking out the snipers."

Levy's friends from school reserved a hall on the kibbutz for the simple wedding. "I left the Suez Canal the day before the wedding, and came back two days later," Tzvika says. "Honestly, I don't remember much about it, except that it was on the kibbutz in front of 400 people. My wife wanted to go on a honeymoon, but I said, 'take a vacation now, in the middle of a war?' Afterwards we went for three days to my sister in Ashkelon. We didn't have any money, so we just slept on the beach, and then returned to the kibbutz three days later."

Not every woman would be as accommodating, but Naomi was obliging to Tzvika's ways then, and – he says – she has continued to be accommodating through their thirty-five years of marriage. An accomplished graphic designer, Naomi went on to study cinema and then holistic massage therapy, and now runs a small massage therapy school on Kibbutz Yifat. She continues to put up with Tzvika's unorthodox lifestyle, which includes bringing numerous lone soldiers home for dinner at little notice, traveling around the country endlessly and being absent from home for days at a time.

"It takes a special woman to put up with this," Tzvika says. "Someone who appreciates the importance of what I'm doing. If didn't have a wife like Naomi, I couldn't do what I'm doing." The couple has four children: Dotan, thirty-three; Idit, thirty-one; Michal, twenty-six; and Mayan, nineteen.

After the war Tzvika continued working on the kibbutz, and started to coordinate groups of youth and soldiers to go to other kibbutzim to strengthen them. For two years he went with his wife and then two young children to live on a fledgling kibbutz at the northern rim of the Dead Sea called Kalia, and brought another eight families with him.

With the country's wars serving neatly as the dividing chapters of Levy's life, the next section began with the First Lebanon War in 1982, in which he fought as a reservist. He saw action in the Shouf mountains in Lebanon, and says succinctly: "We fought well there. We took out 504 tanks and two helicopters."

It was after that war that Tzvika became heavily involved with lone soldiers. He did this pretty much on his own intermittently after the war, going to the Tel Aviv bus station at nights to see if soldiers needed a place to sleep, until the head of IDF manpower – a gravelly-voiced officer named Yoram Yair (Ya-Ya) whom he had known for years from the army – called him into his office and asked him to direct the program for lone soldiers on the kibbutzim.

"I remember that day," Tzvika says. "It was October 1995. Ya-Ya called me and asked me what I was doing. I said that I was studying water engineering and hotel management and working in the kibbutz fields. He said that was all nonsense. 'I have soldiers living in bus

stations because they have nowhere to sleep at night, and you are studying water engineering? That's not for you, go help the soldiers.'"

From that time onward, that's pretty much what he has done.

One of the first things Tzvika realized he had to do in dealing with the lone soldiers was to raise the public's awareness of the whole phenomenon. "The first time that Israel became aware that there were soldiers like this was when a popular Israeli television interview show featured an orphaned Hungarian girl who was serving in the IDF. She was an officer, and her appearance made a huge impression. Until then nobody knew about them."

Levy's drive to raise the profile of the lone soldiers continues unabated. He travels around the country – from kibbutzim to universities to synagogues – lecturing about lone soldiers. Not, he says, looking for people to adopt the soldiers, but rather to raise their awareness, so that when they, or their children or even grandchildren, are in the army, they will have a greater sensitivity to what the lone soldier is going through.

"Ya-Ya gave me an opportunity to fill a vacuum that needed to be filled," Tzvika says. "These are today's true Zionists. I admire them. If it is good for them here, those who return to their native countries afterward will be Israel's best emissaries – the very best. And those who stay here, well, they will be our best citizens. I want it to be good for them here."

The job, however, of making it "good for them here," is not always easy. Not because Tzvika doesn't try, but because Israel's reality itself is so very difficult. The Second Lebanon War in the summer of 2006 is a case in point.

The phone call Tzvika received on Friday, July 27, 2006, was markedly different from the hundreds of other calls he fielded during the first fourteen days of that war.

He answered the call while sitting with a group of friends on his kibbutz, at a forum quaintly known as "The Parliament," a group of some forty men, and one woman, from nearby Jezreel Valley kibbutzim and moshavim who sit together every Friday afternoon in a converted horse-riding clubhouse and discuss the issues of the day over bottles of Maccabee beer, bowls of humous, mounds of salty olives, and plastic plates piled high with cucumbers, tomatoes, and onions.

This group, this "Parliament," represents another Israel, the "old Israel," the Israel of sandals and kibbutz hats, of plowing fields and public sing-alongs, of community and sacrifice.

This group is a throwback to a time when the country was nourished on simpler, more Spartan, values – a time when the kibbutz was indeed a communal endeavor, when the members ate together, and when their children slept in children's houses. Before cable television, before cellphones, before cars for everybody, before the runaway materialism that altered the face and values of both the kibbutz and the country.

The wood-paneled walls of the "Parliament" are papered with pictures of a veritable Who's

Who of Israeli politicians who over the years have came to speak to this small, rugged, rural audience.

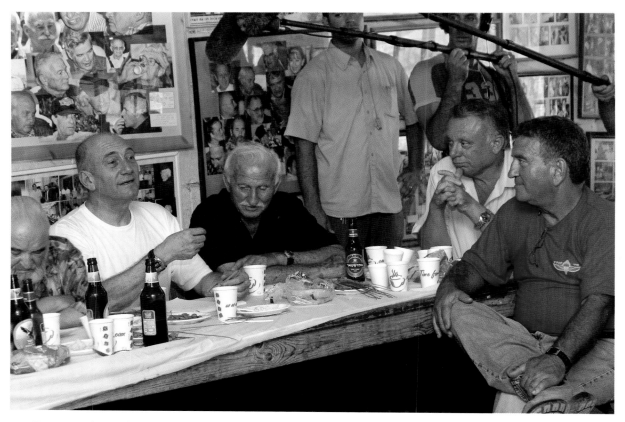

Former Prime Minister Ehud Olmert discusses the Second Lebanon War at a "parliament" meeting at Levy's kibbutz, Yifat.

Here is a photo of former chief of staff Rafael (Raful) Eitan, who lived not far away in Moshav Tel Adashim. There is a picture of Ariel Sharon reclining in an easy-chair in the "Parliament." And over there, in a corner, is a photo of Yitzhak Rabin talking to the members. Through a window that punctures the photo-gallery wall, kibbutz horses can be seen grazing.

"It was here that Rabin announced he would run for prime minister the second time," Tzvika says proudly. "Over there, in the corner," he adds, pointing. "Anyone who wants to make it in politics in this country comes to the Parliament."

But on that particular July Friday in 2006 the thoughts of the "parliamentarians" were not about the country's political situation, but rather about its military dilemma – specifically about the war in Lebanon.

The war had been raging for two weeks, and the promise of the first few days – when Israel pummeled Hezbollah from the air – had given way to a stalemate of sorts where Israel's advances were countered by hundreds of Katyusha rockets on northern Israel. A few of these missiles fell in Yifat's cotton fields.

One of Tzvika's three cellular phones rang. But this time it wasn't an officer asking for advice on how to visit the bereaved family of a soldier who had been killed. This time it wasn't the mother of a lone soldier from Colombia calling to get any scrap of information about her son, somewhere up in Lebanon.

During the war Tzvika received calls from all over the world, from people he didn't know and couldn't communicate with, thirsty for any information about the fate of their sons. All soldiers had to leave their cellphones at the border fence on their way into Lebanon, making communication with family, especially family halfway around the globe, extremely difficult.

"One mother called me from Chile," Tzvika says, picking up a phone to illustrate the call. "She didn't know English, and she didn't know Hebrew. But by the tone of her voice I understood she was worried about her son. Her son had given her my number."

Tzvika happened to know this woman's son, but that wasn't always the case.

"Some of the soldiers I knew, some I didn't," he says. "But even if I didn't, I calmed the parents down, told them that their child was okay."

But the call he received this particular Friday afternoon was different.

"Tzvika, where are you? Put on your uniform, we've been called up," Danny Katz, his commander of many years, said calmly. "We're getting ready." This call wasn't out-of-the-blue unexpected, since Tzvika had talked with Katz a couple of times since the war had begun in anticipation of this moment.

At fifty-eight, Tzvika was one of the country's oldest active reserve soldiers. He was not obligated by law to serve anymore, but rather continued to serve as a volunteer. This, he says, he does out of a sense of duty, of wanting to set an example.

But it isn't all altruistic. The army gives Tzvika meaning, status, a sense of purpose, a sense of belonging, a sense of self.

"Tzvika, they are mobilizing the unit," Katz said. "All the soldiers need to be in Elyakim on Sunday."

As the unit's chief logistical officer, Levy's job was to prepare the Elyakim base for absorbing and dealing with the soldiers, and for readying everything for a few days of intensive training.

Elyakim is a sprawling base that overlooks fertile Galilee fields on one side and the hillside town of Yokne'am on the other. It is a huge, gray camp with emergency storehouses for reserve soldiers and shooting ranges and mock-enemy camps where it is possible to simulate close-contact warfare. It is where reservists stop to pick up their equipment and a few days of training before going into Lebanon.

Within five minutes Tzvika was in his car headed to Elyakim to prepare for the absorption of between 3,000 and 4,000 soldiers. Like a woman in late stages of pregnancy, an overnight bag set aside for a sudden hospital stay, Tzvika always has a bag prepared and ready to grab on short notice. Inside he keeps two uniforms, socks, underwear, shoe polish, a razor, helmet, eight full submachine-gun magazines, and *My Michael*, a book by Amos Oz.

On the way to the base he already got a taste of the war, as three Katyusha rockets slammed down near his car. He got out of the car and – since he was in a uniform designating his lieutenant-colonel rank – directed traffic and told people to lie prone in a nearby irrigation trench.

"I got to the base at 3:30 PM," Tzvika says. "We prepared the base for the 3,000 soldiers. The next day the training started – shooting, helicopter drills, simulating fighting in built-up areas. It's in my blood."

For two weeks the soldiers of his reserve paratroop unit were quartered at a college dormitory in Afula. And then on August 7 they received their orders to move north.

The morale of the unit – made up of husbands and young fathers, accountants and students, bodyguards, lawyers, and storekeepers – was still good at that point of the war.

"There was definitely concern," Tzvika says. "But spirits were still high. People thought the decision to go to war was right, but were asking why the ground troops were not brought into Lebanon immediately."

After the war, Tzvika's criticism of the war's execution became intense, like that of many of his countrymen. He complained that the leadership – both political and military – was indecisive, and that the officers relied too much on high-tech warfare, forgetting about the basics of soldiering.

He lamented that the army's overall preparation was poor, that military storehouses were not full, and that soldiers were sent into battle before a "fire lane" was secured for bringing out the dead and wounded.

But he had no criticism for the run-of-the-mill soldier, the everyday Israeli grunt. They remained, he says, highly motivated, caring for one another, and dedicated. Likewise, Tzvika says the "loneliness" of the officers was "nothing to envy," and they often had to make split-second, life-and-death decisions by themselves.

Some two and a half years after the July 2006 war, following Operation Cast Lead – the three-week military operation against Hamas in the Gaza Strip that ended in January 2009 – Tzvika says it was clear that the army internalized and learned the lessons of the Second Lebanon War.

"Everything was different," he says. "The army was prepared, the officers led in battle, there was no problem getting food and water to the soldiers, the different branches of the army – the infantry, air force, and navy – worked together in unprecedented unison. It was a completely different opera."

Back in 2006, however, the jumping-off point into Lebanon for Tzvika's unit was near a northern kibbutz called Shomera. The convoy into Lebanon was supposed to start rolling at 10 PM – under a clear sky on a chilly summer evening.

The orders were late in coming, however, and the force didn't move until midnight – a mistake, since there was a full moon and Hezbollah fighters were being aided by moonlight in monitoring their movements.

The force crossed the border and then, inexplicably, stopped in its tracks. The soldiers waited. At about dawn, after watching planes and missiles fly overhead, they continued to hike to the village of Debel in southern Lebanon's central sector. They arrived near sunrise.

The force fanned out and – contrary to many of the soldiers' intuitive feelings – took up positions in different houses in the village. The original plan was for the force to go to an entirely different village. Tzvika remained at the outskirts of the town.

From one of the houses they had taken over, a couple of soldiers went outside to relieve themselves, and – Tzvika says – their position was discovered. A Russian-made Kornet missile was fired and hit the house, setting off explosives carried by the demolition unit. The house collapsed, killing eight soldiers and one officer. Another thirty-one were injured.

Mayhem ensued as problems emerged when organizing the evacuation of the dead and wounded. There was talk of using armored trucks to evacuate, but that was scuttled. Then there was talk of a helicopter evacuation, but that, too, was deemed too risky. In the end the troops marched with the dead and wounded on dozens of stretchers nearly five kilometers to Shomera on the border, over rocky, brush-covered terrain. The fifty-eight-year old Tzvika, who had helped carry stretcher-laden injured out of the Gaza Strip some forty years earlier, helped lug the stretchers.

Tzvika says that the horror of the sight didn't incapacitate him, since he had seen it in other wars. At Shomera the badly wounded were bundled into helicopters for the ten-minute flight to Rambam Hospital in Haifa. Tzvika raced there by car.

On the way he received a call from one of his officers, who said his own radio man was among the wounded and was carrying highly classified information in his underwear.

"I ran to the arriving helicopter before the doctors got there. I reached the radio man, who was critically wounded. I dug inside and took out the information. It was the names of Hezbullah officers inside a bloodied plastic bag. I took it and burned it."

For the next few days he stayed at the hospital, comforting the wounded and their families, sleeping at their bedsides, looking for lone soldiers.

The lone soldiers, he says, related to the war differently than the other soldiers. Of the forces that fought in Lebanon, some 300 were soldiers without family in Israel. Five were killed, twenty-eight were wounded. About the same number of lone soldiers were involved in the Gaza operation. Four were wounded, none were killed.

"The worst thing, the saddest thing, is when a lone soldier falls," Tzvika says.

"The lone soldier leaves his mother and father back home, say in Argentina, comes here and is all alone. Then he goes into Lebanon. In the worst case, he goes back to his parents in a box. 'I sent you a healthy boy,' the mothers say. 'I knew the dangers; I didn't want him to go into the army.' But he said, 'I am not asking you, Mom, I'm going in.'

"Michael Levin didn't ask his parents," Tzvika says of the twenty-one-year-old Philadelphia native who fell during battles with Hezbollah in Aita a-Shaab during the Second Lebanon War.

"Yonatan Sergei Vlasyuk, who went into the Egoz commando unit, didn't ask his father, who is a brigadier-general in the Russian army. He didn't ask him if he could come here. He didn't ask his mother either, who doesn't live here, and who is not even Jewish. Yet he dies for Israel, and they send him back in a box."

Vlasyuk, twenty-one, was killed in exchanges of fire in the Lebanese village of Maroun al-Ras just across the Israeli border.

"This breaks my heart," Tzvika says. "When I'm in synagogue they are in my mind – the realization that they are doing ten times what my son, who is an officer in a commando unit, is doing. It is so much easier for my son, because he has his mother and father here, he has support here."

The lone soldiers, Tzvika says, were highly motivated to go into Lebanon during the war – more so than the regular soldiers – because they felt they had something to prove.

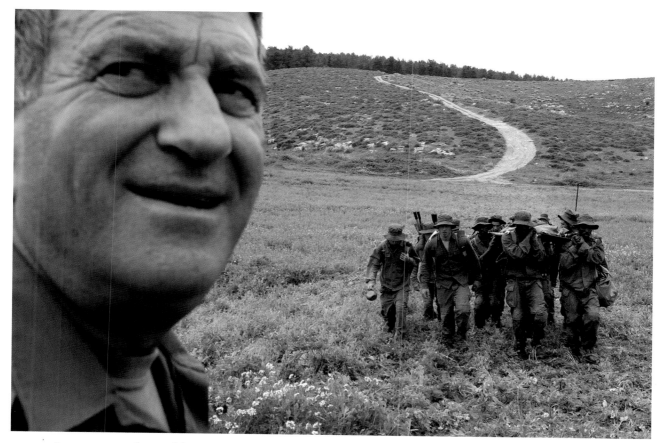

Levy supports lone soldiers during grueling tryouts for elite paratrooper units.

"Michael Levin was on a vacation with his family in Pennsylvania," he says. "He cut short his vacation to come back and be with his unit. At first they were not going to let him go into Lebanon, but he fought it, and said, 'What have I been training for over the last two years?'"

"The Israeli kid who was born here needs to go into the army, it is a given, expected," Tzvika says. "But the kid from the US or Russia looks at it differently. When there was a need for someone to volunteer and cross a dangerous road in Lebanon, and no one volunteered, Michael did so. He said, 'If I don't do it, no one will. I'm an immigrant, I'm a Zionist. I'll cross the road, and when I do, others will follow.'"

After Levin fell, one of his friends, a lone soldier from Sweden, a boy named Tamir Meir, phoned Tzvika, and asked to stand next to him at the funeral.

"He didn't leave me the whole funeral," Tzvika says. "He hugged me the whole time, I hugged him. He didn't have parents here to stand with him at the grave, so he called me. He called and said he didn't want to go to the funeral because he didn't know if he would cry, and what his friends in his unit would say. He said he looks at all the soldiers who come to these funerals with their families, and feels envious – and that it would be different were his father or sister here to comfort him. 'I am alone here,' he said. 'I come from Sweden. There are no Swedes here, no one to speak Swedish to at a time like this.'"

Tamir also called Tzvika before he went into Lebanon, and in a cryptic fashion let him know where he wanted to be buried if something happened to him.

"Tzvika, you know what I want to tell you but don't have the nerve to say it," Tzvika recalls the soldier as saying. "I knew what he was talking about, and said, 'Okay, where – Mount Herzl or Kibbutz Sde Eliahu?' He wanted to tell me where he wanted to be buried, but couldn't get the words out, he couldn't come out straight and say it."

Then, playing the role of the boy's father, Tzvika dispensed advice that the boy's father would have given had he been in Israel and able to talk to his son.

"I said to him, 'Go inside, go into Lebanon, and God will look after you, but first and foremost look after yourself. Be a good soldier. Even during the long breaks don't take off your helmet. Don't take off your flak jacket, even for a minute. Even if everyone else does, don't you do it. Keep your eyes wide open all the time to watch over yourself and your friends. Look after yourself. Keep your eyes open. Always. All the time."

think if you play the game it's ten times easier. There are people who can't take it, but I'm okay with it."

What has taken Botham a bit more time to "get okay" with, however, is the guns. "I'm not too keen on the guns," he says, adding that the first time he touched one was when he was on the religious kibbutz, at a short paramilitary training course.

"When I shoot more, I'll get more used to it, but now it's a bit too much. I'm from England, you know, so all of a sudden, standing in a row of people with rifles, everyone shooting, some people not understanding everything so well, is a little frightening.

"You are at the firing range at night, and the officer is speaking, and there are glow sticks all over the place, and no one is listening because they all want to shoot, and she asks if anyone has any questions, and nobody does because they want to shoot already. But they don't really understand that well what is going on. That's a little frightening."

Toward the end of the program at Michveh Elon, an army manpower officer came to the base and asked the soldiers which units they wanted to join. Botham's first choice was the Golani Brigade, the unit he was – in the end – accepted into. He says he just wanted to go into a regular Golani unit, and not one of their elite commando groups. "I don't want to be a hero," he says.

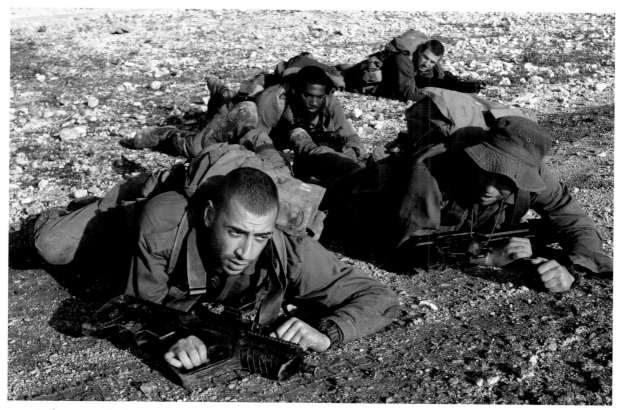

Botham crawls through muddy terrain during training with his Golani unit.

Having just finished the Michveh Elon program, Botham is facing another two more years in the army, including some nine months of the physically taxing basic and advanced training in Golani. This will be followed by revolving stints of duty on the Lebanese border, in the West Bank, and on the border with the Gaza Strip.

Asked if he is afraid, Botham responds, "No, not at all. I'm stupid, man. I don't think about things until I'm actually there. I was fine about going into the army, until that morning when I actually had to show up, and I said, 'I can't do this, I'm going to a coffee shop.'"

But he did do it, and was able to cope. The same, he says, will be the case in Golani. "At first it'll be like, 'Oh no, what have I got myself into,' but then I will get over it."

Regarding the fear factor, Botham says he was thinking about the danger of the army the day after a terrorist on a bulldozer rammed into a number of cars on a busy Jerusalem street in June 2008, killing three people.

"I was thinking that had I not been in the army then, I could have very well been on that No. 13 bus on the way to Talpiot when the madman crashed into it, and I could have been crushed. But I was in the army, I was in the canteen, I was buying cigarettes, and drinking a Red Bull. So you can't say that one thing is dangerous, and the other isn't. Stuff happens everywhere. I feel safer in the army, on a base surrounded by soldiers. It gives you a sense of security."

But, obviously, he will not always remain on the base, but rather in a matter of months be patrolling borders, manning roadblocks, apprehending terror suspects in the West Bank, and possibly fighting inside the Gaza Strip – duties that will place him squarely in objectively dangerous situations.

"I'll cross that bridge when I get there," he says. "I'm not thinking about it that much. If you think about it, if you watch those videos on YouTube about what some of the units are doing, and try to hype yourself up for it, it doesn't do you any good. I'm doing the army. I want to do it, and get it finished. I know it will be dangerous, but I'm just taking it as it comes, man. I'm just doing it; just doing it."

CHAPTER 3

Isabelle Fhima

Morocco

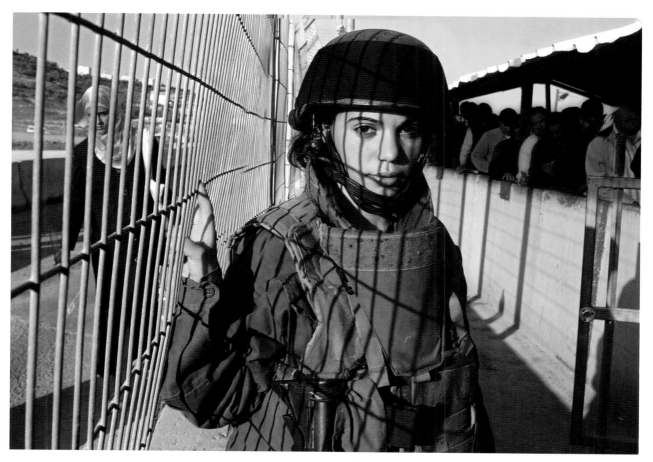

Isabelle Fhima on duty at an IDF checkpoint in the West Bank.

A man in his mid-thirties plays with his young son at the entrance to a high-rise apartment building in Ashdod on a Friday morning in August, as a visitor arrives looking for an army-aged woman who lives in the building.

"Do you know Isabelle Fhima?" the visitor asks. "She's a soldier who lives here somewhere."

"Why?" The man asks, suspecting the visitor is from the army. "Did she go AWOL?"

The man obviously doesn't know Fhima. Because if he did, he would have known that not only was she not absent without leave from the army, but that she bucked the will of her parents and came to Israel from Morocco precisely to enlist: not exactly the normative path for a kid growing up in Casablanca.

The IDF has thousands of soldiers in the army who grew up in homes where their parents spoke the Moroccan dialect; who feasted on couscous, stuffed dates, and kebab; whose grandparents waxed nostalgic about Casablanca, Marrakech, or Rabat; and who – in this land where the country of one's parents' birth defines a person's Jewish "ethnicity" – are considered Moroccan. But the IDF has just a very few soldiers who themselves – not only their parents or grandparents – were born in Morocco, and who immigrated not in the 1950s and 1960s, but rather over the last few years.

Fhima is one of the few, and – in this regard – is something of a curiosity. Israeli children of Moroccan Jews, those reared on stories of King Hassan II, a backward country, and long treks over the Atlas Mountains to make aliya and live in tent camps in Israel, have a difficult time pegging her.

"When they hear I am from Morocco, people my age ask what it's like to live there, whether there are cars, how I got here," says the twenty-one-year-old Fhima, in a lilting French-accented Hebrew. "I remind them that it is not exactly the same Morocco their grandparents left fifty years ago, that it is a modern country. It is an Arab country, but it is modern."

Modern or not, it is not a country where Jewish youth, or their parents, see much of a future.

The Moroccan Jewish community has gone from some 250,000 in 1948, to about 4,000 in 2008. And even though the current king, Mohammed VI, has taken pains to show support and protect the Jewish community, especially after al-Qaida linked terrorist bombs against Jewish targets in Casablanca in 2003, most Jewish youth leave there after high school. And most of them leave for other locales, not Israel.

"The way it works in Morocco," says Fhima, stroking long, thick, wavy brown hair, "is that you go to high school, do the matriculation exam, and then go abroad for university. There are no good universities in Morocco, so the Jews go elsewhere. Everyone goes to New York or France or Canada. They don't stay in Morocco."

Of her class of some twenty-five at the Alliance Israelite school in Casablanca, a Jewish school that also accepts a small number of select Christian and Muslim students, nearly everyone left Morocco after high school. She was the only one to come to Israel.

Speaking of her Jewish classmates, and why they showed little interest in studying in or moving to Israel, Fhima says they "didn't want to go to a country where there are problems, I don't think they wanted that pressure. To a certain extent, I think they were afraid."

Which, considering the portrayal of Israel in Morocco, is not entirely unreasonable. But rather than scaring Fhima away, the unbalanced representation of Israel at home only increased her motivation, since she was convinced Israel was much different from what was being depicted in the media.

"My mother had friends in Israel who would come to visit, and we also had some cousins there whom I would talk to on the Internet," she says, sitting on her porch during a four-day leave from her base in a sleeveless, rainbow-colored blouse, her green army fatigues drying on a clothes line just over her shoulder. "From time to time they would come to Casablanca. They talked about life in Israel, and told me how after high school the kids go into the army."

That talk had an impact, and from the time she was about ten years old, Fhima says she realized she too wanted to join the Israeli military. "I remember people asking what I wanted to do when I grew up, and I would say, 'go to Israel and go into the army.' And everybody would laugh."

Fhima's interest in the army is, to a certain extent, inexplicable. She knew absolutely nothing about the military, and says she was even unaware until a certain age that all countries had armies, because the army played such a low profile in Moroccan life. Nor did she have any interest in action movies.

Her relatives' talk about the IDF, however, piqued her interest, and she began to pay attention. She would watch shows on satellite television that dealt with Israel and discussed IDF soldiers, shows that were beamed late at night and painted a different picture of the IDF from what was shown on the state-run media.

"I saw those shows and said, yes, that's the contribution to Israel I want to make, I have to give something. If we do not defend Israel, who will? It was something I felt the need to do."

Fhima's mother, a social worker who worked with Jewish community organizations in Morocco, had over the years helped send destitute Jewish kids from Morocco to Israel, and Fhima recognizes that her mother's work, to a certain degree, helped mold her Zionism. The rest, she says, just came from "deep within."

"I lived with my mother and grandmother until I was ten years old," says Fhima, whose parents are divorced. "[My grandmother] was like another mother to me. I was not Shabbat observant before she died, but when she died it was a huge trauma. I pledged that from then on I would observe Shabbat, and become more religious. I'd say that now I am traditional."

But being a traditional Jew in Morocco, indeed being any kind of Jew in Morocco, is no easy task. A common theme that runs through Fhima's recollections of her native land is that as much as the king has managed to keep a lid on anti-Jewish manifestations, and as little as she felt overt anti-Semitism, it was still a strain to be a Jew there.

"It is possible to live there as a Jew, but you feel it when you come and go. People stare at you," she says, adding that the Jews in Morocco are – because of their facial characteristics – easily identifiable. With olive-colored skin and large, brown eyes, Fhima looks distinctly Mediterranean, and those Jewish characteristics of which she speaks are not immediately apparent. Yet, she says, in Morocco it was as if she wore her religion on her face.

"It is not too comfortable an atmosphere," she says, adding that there have not, however, been the isolated incidents of beatings of Jews that occurred sporadically in France during the early 2000s. "You live well, but there is always that thing you have to hide – that you are Jewish."

Five-year-old Fhima celebrates a Moroccan Jewish ceremony with her parents, grandmother, and rabbi in Casablanca.

One of the most refreshing things she finds about Israel is that she can walk around without feeling all eyes are on her; that she can apply for a job or for school and not be concerned she will be rejected because she is Jewish. This was her strongest impression of Israel when she visited for the first time in 2004 as a participant on a two-month program for Moroccan Jewish youth going into the twelfth grade.

"I liked the feeling that I would walk in the street and nobody would look at me," she says. "You feel yourself, that nobody is going to do anything to you because of your religion. I felt free in my soul. I had no concern when I walked around that anybody would stare. That's what I felt here. I felt that I could breathe at last. I wanted to stay."

Fhima called her father and said she was interested in remaining in Israel, and that it would be possible for her to finish high school and pass matriculation exams at a French-language school in Jerusalem. But he didn't like the idea, saying the adjustment would be too difficult and it would be too hard to take the matriculation exams in a school in which she didn't know anybody, and would have no friends with whom to study and prepare. He insisted she finish her matriculation in Morocco. After that, he said, she could return to Israel.

Fhima recognizes now the common sense of her father's directives, since it would have been difficult passing the matriculation exams in a new school, in a new land, in a new language and with no close friends. Yet, she says, returning to Morocco was also complicated.

"Before you see a place, you can only imagine what it's like. But after you see it, and like it, it's difficult to leave. For two weeks after I returned, I just went to school and then home; school and home, I had no interest in anything else."

During that year back in Casablanca, as her friends were applying to universities abroad, Fhima was preparing her return to Israel. She met with Jewish Agency emissaries, and

they directed her to a college preparatory program in Tel Aviv connected to Tel Aviv University.

It was on that year program that the previously sheltered Fhima met people from all over the world, an experience she says was invaluable. "I learned a great deal just from the people," she says. "I didn't know beforehand there were Jews from India, but I came here and met Jews from India. I met Jews from Colombia, Australia, everywhere. It was an eye-opener."

Her parents had no objection to her coming to Israel to study – though her mother would have preferred she go to New York, where an aunt lived – but they did not share her enthusiasm for going into the army.

Fhima's mother was opposed largely because she thought that if Isabelle did the army, she would then – like many of those who finish the IDF – travel abroad for a spell after her two-year army service ended, and as a result would probably not go to college and earn a degree.

While Fhima's mother was well aware of her daughter's desire to join the IDF – Isabelle had talked about it for years – she never took it that seriously, believing it was just a passing phase, and that while her daughter liked to talk about it, she would not actually carry it through.

Her father's opposition was stronger: He didn't think the army was a place for a young woman. He understood why boys were needed in the army, but not girls. So with neither parent supportive of her decision to join up, Fhima went back to Casablanca at the end of her year of studies in Tel Aviv, just prior to induction, to try to explain it to them in person.

"I went there to talk to them about my decision," she says. "My father didn't agree on the phone, so I thought that if I went to talk to him, it would be better. It wasn't. He did not speak to me for four months afterwards."

Eventually, she says, her father came to terms with the notion, and – she has been told by other relatives – is proud of her. She now talks to him on the phone, but doesn't tell him much about what she is doing –more out of a concern that the phone lines are not secure, and someone might be listening to the conversation to Morocco, than any lingering anger he might still have over her decision.

Fhima admits it took a lot of strength to go against the wishes of her parents. "It is good to listen to your mother and father, I realize that," she says. "I told them I was listening to them, but had to do what was good for me. They also did things their parents didn't want them to. It is impossible to always do what your parents want."

Fhima says a Holocaust-related book she read helped her during this tug-of-war: Martin Gray's *Au nom de tous les miens* ("For those I loved").

"He told about his life, how he lost all his family in the Holocaust, and – after he went through all that – how he returned to build a normal life. He showed that it was possible to overcome the most difficult things.

"That gave me strength to come here," she says. "It is difficult to live in Israel, difficult to leave your friends, leave your family, and the places you're familiar with to go to a new place,

new people, and a different language." But, she says, stressing that she was in no way comparing what she faced to the tribulations of the author during the Holocaust, "this book showed how it is possible to overcome difficult things. I thought that what I'm doing may be hard, but it is not as hard as what he faced, and he overcame it – so it is possible to leave everyone and come live here."

Fhima's difficulties carried over to having to get used to the army, a framework with which she was completely unfamiliar before she arrived. All she knew about the IDF came from some television programs she saw in which IDF soldiers were interviewed, and bits of information culled from a cousin who immigrated and served in the army. But his experience, as a boy, was obviously different. She went in cold.

She went in, however, with a friend – a new immigrant from France whom she met in Tel Aviv on the university preparatory program – which helped cushion the initial shock. She also went in knowing that she did not want to serve two years as a clerk, but rather wanted a challenge, preferably as a combat soldier in Karakal, the IDF's only mixed-sex infantry battalion.

Fhima was told candidly at the induction center when she began the induction process that the IDF could not promise her any particular job or unit, and that she would have to do basic training and take her chances on an assignment after that like everyone else. The clerk then asked if she still wanted to go through with it, or preferred to continue her studies. She joined up.

Her first stop, like so many other lone soldiers, especially those with limited Hebrew, was Michveh Elon, and two months of ulpan and basic training combined. While Fhima's Hebrew had improved dramatically since she first arrived, it still needed some work. In addition to Hebrew, she speaks English and French, understands Moroccan, and is rapidly picking up Arabic.

"It was weird to see so many new immigrants there, most of them Russians," she says of her first impressions at Michveh Elon. "But there were others as well. I remember a twenty-three-year-old woman from Texas. You saw people who wanted to come to Israel especially to go into the army."

One of the oddest things in the beginning, she says, was the absence of Hebrew in her immediate surroundings. "It felt a little weird. You come to Israel, go into the army, and then don't hear Hebrew. All I heard was Russian, and I didn't understand anything. I would try to speak to the Russian girls in my not-so-proficient Hebrew at the time, but they didn't understand me. Then I tried English, but that didn't work. I didn't know anything, and thought this was the way things were going to be for the next two years. But, obviously, when you finish basic training and leave Michveh Elon, things change dramatically and, finally, there is Hebrew."

Fhima, who smiles broadly and laughs easily, downplays the initial shock and the difficulty

of basic training. "If you are doing something that you want to, then everything becomes easier," she says. "I told myself that I was entering the army framework, and that what they tell me is the way it will be. That was my attitude: that you can't go against them."

Following basic training, she went to the officer responsible for further assignments and said she wanted to go into the Karakal unit. "I didn't see myself working in an office," she says. "I wanted to give the maximum."

A bureaucratic mix-up – her file was confused with someone else's and she was given a medical profile that precluded her from being in a combat unit – kept her out of Karakal. Although it was a mistake, she was told it would take weeks to correct, and in the meantime she was shunted off to a course in the Border Police combat support unit that checks Palestinians at roadblocks.

"My father called during that period and asked how it was going," says Fhima, who was deeply disappointed at the time. Unable to tell him the truth, because he so opposed her coming in the first place, she said everything was fine. It was a lie, because she was unhappy at not knowing where she would be, and disappointed at not getting into the unit she so badly wanted.

Nevertheless, she went to the Border Police unit, and was happy to hear it was "like combat," and that she would be stationed at a checkpoint near a large West Bank city screening Palestinians.

Asked why exactly she wanted to be in an area of tension, she says, "because it is important, because there I feel I am contributing something."

Indeed, the checkpoint she has been assigned to frequently makes the news, now for a suicide bomber stopped on the way to Israel, then for attempted stabbings of the soldiers there. It is not exactly a unit that people are standing in line trying to get into, which means it is small, and also – Fhima says – full of people with a great deal of motivation.

"It is difficult work," she says in obvious understatement of her duties. It is done while wearing full body armor in hundred-degree heat in the summer, and while standing in the driving wind and rain in the winter.

"The best thing about the unit is that the people who are there want to be there. That already is a good start and makes everything else easier," she says. She became so fond of her unit – a group that includes two other female lone soldiers –that even after she succeeded in raising her medical profile, she decided not to try to transfer to Karakal but to stay where she was.

Her unit is one of the last trip-wires, one of the last lines of defense against people smuggling explosives or suicide bombers into Israel, and it can't be manned by people who are not committed to being there. The job takes complete focus. "If someone doesn't want to be there, they won't do a thorough check, and that will endanger the rest of the country."

Is she afraid?

"Not everyone coming through the checkpoint is trying to blow themselves up," she says, avoiding a direct answer to the question. "If one of the kids comes to blow himself up, or bring

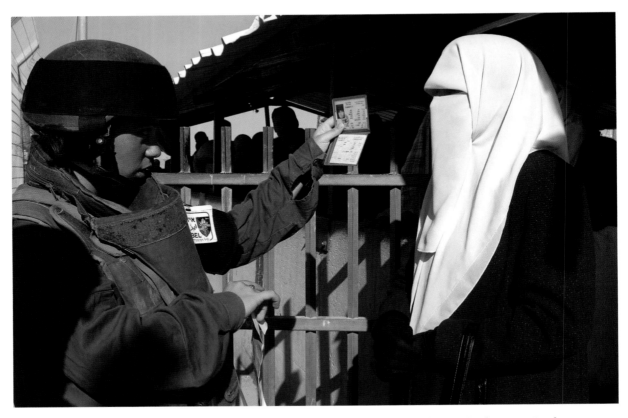

Fhima struggles to identify a veiled Palestinian woman at her IDF checkpoint in the West Bank.

something in, you stop him, and then you feel that you have done something vital for the country."

And it is doing something vital for the country, she says, which makes the work bearable, since the actual job itself is not something very "likable." But, she adds, "What I do like is doing something I feel is important."

Edden Friedman

United States

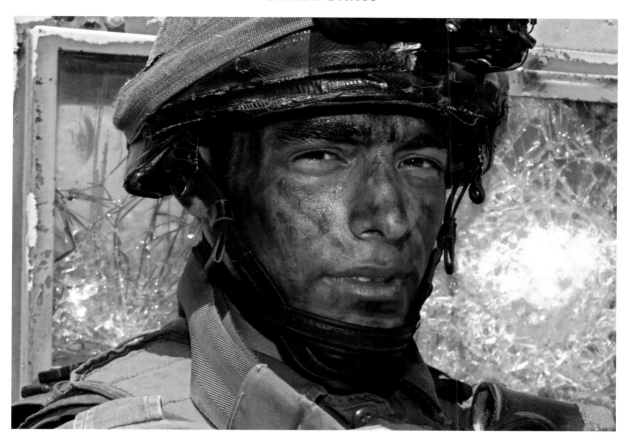

Edden Friedman trains with his elite paratrooper unit near the Gaza Strip.

On the outside, the IDF's pull seems almost unfathomable.

Considering the constant fatigue, the intense physical and emotional pressure, the hazards, the violence, the lack of freedom, the regimentation and the difficult living conditions, eyebrows are invariably raised when soldiers say, as many of them do, that they enjoy – even love – the service.

Somehow, speaking in glowing terms about the army – of sitting in the mud in an ambush for hours, of bursting into a home in Nablus to arrest a terrorist, of hiking dozens of kilometers with sixty pounds of gear on one's back – comes across as a bit ingenuous. What about the

danger, the discomfort, the pain? Skiing is fun, watching a movie is enjoyable. But three years in the Israeli army?

Edden Friedman, a twenty-year-old New Yorker, is in an elite paratroopers commando unit, or *sayeret,* called Palsar. He explains the attraction:

"What is there to love?" he says, mulling over the question asked after he insists that he is enjoying his service. "It's like being in a locker room twenty-four hours a day: being with the guys, hanging out, laughing a lot."

And Friedman knows from locker rooms. A former high-school hockey player, he also played at one time for the Israeli junior national hockey team. This was possible because his parents lived in Israel for a few years in the 1980s and he was born in the country. He moved back to the States when he was two, coming back for a year after high school on the Young Judea Year Course. From there he went into the army.

"My dad was in the army when he was here," Friedman says, flashing a grin. "He went in for a year and a half when he was twenty-six, and then he did reserve duty. I heard a lot about it growing up."

Moreover, Friedman says, his father had a very close friend who was a paratrooper and who stayed in Israel. And his father's friend – "he's almost like an uncle to me" – loved the army.

"My dad's friend would tell me that he would lie in his foxhole after a long day of training, aching and with thorns in his butt. He told me that what went through his mind at those times was, 'I'm doing this for the Jewish people.' That's a pretty crazy thing to think – all that pain is not for me, it's for the Jewish people, for all the people of Israel.

"Sure, it's physically tough," Friedman says. "Being hungry and tired all the time, it's not easy. The training is tough; the running up and down hills is tough. But there is something about it. It's hard work, but there is a satisfaction, knowing you are doing it with your guys, your brothers-in-arms, and knowing that you are not doing it for yourself, but for other people."

At one time, after al-Qaida brought down the World Trade Center in 2001, Friedman – at the time a US adolescent who was always interested in the military – toyed with the thought of someday joining the American army.

"After 9/11 there was a feeling in America about the importance of going into the army and making a difference. I thought about it. I thought about joining the Marines or something like that. But the American army is very different than the IDF. Here you go in, and then come home on the weekends. It's not exactly like that in the US military."

Indeed, new recruits who are drafted into the IDF on, say, a Thursday go through a whole emotional scene with their parents at the induction center, and then – as they get on the bus – say "See you tomorrow" to teary-eyed parents. Generally they will get out the next day for Shabbat. If they are inducted on a Monday, they will have to wait four days to get home. Throughout their service, Israeli soldiers get home on average about every second Shabbat.

"The whole head is different," Friedman says. "I grew up watching war movies and stuff like that – *Full Metal Jacket*. There are all those scenes about Marine basic training, and the

drill sergeant yelling at the recruits, and hitting them and throwing them on the ground, and how the trainees have to stand at attention, not move or bat an eyelash. Well, the Israeli army is not like that at all."

Friedman says his commanders in basic training demanded discipline, but did not obsess about the small stuff. "My commanders were very disciplined," he says. "They looked perfect, no flaw in them whatsoever. But if you were standing at attention and had to scratch your eye, or you moved, or your beret was not exactly straight, no one was going to care.

"If I went to the American army I'd get free college and all kinds of benefits. But there is a difference in the way the army is run and everything, and there is also a difference when you are a Jew in a Jewish army."

A key difference, he says, is the feeling of seeing the immediate benefits of one's toil.

"Last Tuesday I was on a mission around Jenin and we caught two terrorists who were working on putting together a suicide bombing. I know that by picking up those two terrorists we saved lives in Tel Aviv, Netanya, and Jerusalem. You feel every night when you go on a mission that you are making a difference."

But it's not all lofty ideals. True, Friedman grew up in a very Zionistic family in White Plains, New York, spent time in Israel , and went to Jewish day school, but he was also attracted to the IDF by its more earthy aspects – by the macho excitement of it all.

"I'm a twenty-year-old guy playing with guns, having all this crazy equipment," he says, smiling widely. "When I talk to my friends at home they'll say something like, 'Yeah, I had a hard test this week. I had finals, a big paper.' I'm like, 'that sucks.' Yeah, this week I was running up a hill, shooting targets, throwing grenades, driving around in a Humvee."

Friedman's contact with his buddies from White Plains High, now in US colleges, has understandably tapered off. First of all he doesn't have much time to maintain the contact, only about an hour each night to make calls, shower, and enjoy some down time; and secondly, it is becoming difficult to find common ground.

"At first I talked to them here and there, and they talked about their papers and their parties and it all seemed kind of trivial. I have no way of explaining what it is like living in a foxhole, eating a can of tuna a day, sleeping out in the freezing cold. Until you do those things, you have no idea what it's like. It is tough to connect."

This doesn't mean he has cut himself off from his past. The walls of his neat and orderly room on Kibbutz HaMa'apil, located in the Hefer Valley near the coastal town of Hadera, is decorated sparingly with a New York Mets baseball cap and a New York City ski hat – reminders of home. There's also an Israeli flag.

"I try to keep it clean so I don't get cockroaches," Friedman says of his room, deflecting compliments on how orderly it looks. "Once I came back after not being here for three weeks, and it was full of cockroaches. It was disgusting. Look, I'm here two days out of every fourteen, I can keep it clean."

The room has a bed, a small table, a mini-refrigerator – a bit larger than the mini-bars in

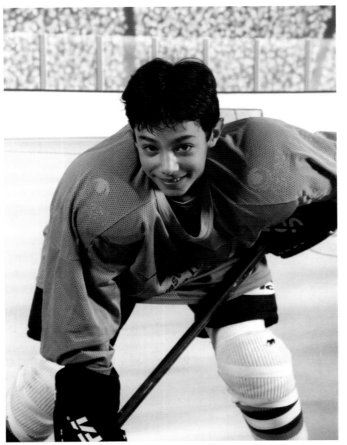

Friedman competes in high-school hockey in suburban New York.

hotel rooms – a microwave oven, television set, sink, and bathroom. All that is provided by the kibbutz, which is paid NIS 700 a month by a non-profit organization based in England to house lone soldiers. "The DVD player is mine," he says, pointing to the top of the TV at the foot of his bed.

Friedman, with short black hair and an equally short-cropped beard, sits at the small table and brings out a carton of apple juice. He wears gym shorts and a bright-orange muscle-man T-shirt emblazoned with the Paratroopers' insignia and the words "Paratroopers Commando Unit."

His shirt highlights a stocky, well-built, solid frame and arms the size of bread loaves. It is an early Friday afternoon, and Friedman has just returned from his base – only about a fifteen-minute ride away – to his room.

He has already showered and stored away his uniform and weapon. His crimson-colored army boots are nowhere to be seen –as if on the weekend he doesn't want to be bothered by reminders of the rest of the week.

The room has a four-door closet, upon which are lined various books about military subjects, and some DVDs. One that stands out is *Animal House*. The air conditioning makes the room – on a hot, muggy day – bearable.

"The room is great," he says. "I have no complaints."

Indeed, the setting couldn't be more pastoral. Pine trees line the road to his room, located in a two-story building that houses a total of sixteen lone soldiers, all of them in combat units. As far as the scenery is concerned, it's like living in a park.

There is a room nearby with a large communal refrigerator which the kibbutz stocks full of food for the lone soldiers. "There is always cheese and meat and vegetables and milk and stuff like that. I don't have to worry about food."

In addition, when he moved to the kibbutz – which has undergone privatization and is now a kibbutz only in name, but with none of the collective trappings of its former self – he was assigned an adoptive family to look after him.

"They are great," he says. "They call to see how I'm doing, they pick me up from the junction, they bake me cookies here and there, and they have me over to eat on Friday night."

Friedman says he gets back to the kibbutz for Shabbat about once every two weeks, sometimes once every three weeks. "In the summer it's much better here because you can go outside, and there are people around and the pool is open. My friends will call and we will go down to the beach. In the winter it's more depressing; winter is always more depressing – there is no pool, you can't go outside so much."

He says he doesn't much mind coming back to an empty room, and that after two weeks straight living in close quarters with his unit, it's good to have a little space. A girlfriend would be nice to relieve the loneliness, he says, but then adds as an afterthought that a relationship while in the army also has minuses. "You're in the army and she's calling you all the time and stuff like that. You never see her – it's a problem."

There is no mistaking, however, that Friedman's reality when he leaves the base and goes back to his kibbutz room – despite the best efforts of the kibbutz and those who look after lone soldiers – is fundamentally different from those of his comrades.

For a brief period in the summer of 2006, Friedman felt what the rest of the guys in his twenty-member unit feel like when they go home. His family came to Israel for a wedding, and his mother and one of his two sisters – he also has a younger brother – stayed on for two months in Jerusalem.

"During that period I didn't feel like a lone soldier," he says. "It felt completely different." How so?

"You come home and Mom gives you a hug, and your little sister gives you a hug. They ask how your week was. Your laundry gets done, there's food in the refrigerator, and you don't have to worry about where you are going to eat on Friday night. You don't have to worry about all kinds of little things. You know you are going to go home on the weekend and see Mom. It's nice to see Mom."

It's not easy being so far away from home, he readily admits, although he has already lived on his own in Israel for some three years.

"I know people go away for college in the US, and that they go to the other side of the country, but it's different. They know they can go home whenever they want, they can just take a flight and go home. I know that I'm not going to visit my parents any time soon. I haven't seen them for six months, and don't really know when I will see them again. It's hard. The holidays are hard, sometimes the weekends are hard, but you deal with it."

This particular hardship places him in a somewhat contradictory emotional situation. While he identifies the difficulty of not having his family here, and appreciates that his commanders recognize his special situation, Friedman also doesn't want it to be over-recognized.

Like new immigrants anywhere, Friedman's ultimate goal is to fit in, be like everyone else. His living situation makes that difficult simply because he is not like everyone else.

"Every holiday they bring all the lone soldiers together for a toast," Friedman says, explaining a tradition that has developed in the army over the last few years. "I hate those things. It's always like, 'Yeah, its great that you are here, without your parents; that you are fighting, without your parents; that it must be hard for you, without your parents.' I'm like, 'I know, I know, you don't have to remind me. I just want to be a regular soldier.'"

Friedman says that the acknowledgment at such events is nice and well-meaning, but a bit forced and artificial.

"The rest of the guys in my unit are working as hard as I am," he says. "All the lone soldiers stand around, we don't know each other. It just kind of feels weird."

As a lone soldier, Friedman says he has benefited greatly by having made it into a commando unit, a sayeret. These units are generally smaller and closer knit than the larger battalions, and attract a highly motivated cadre of soldiers, guys who push themselves extremely hard.

"My biggest fear in basic training was getting injured and not being able to get into a combat unit, or not being able to make it into the sayeret," he says. "I couldn't sit in an army office for three years and do some mundane job. I just couldn't do something like that."

While Friedman pushes himself hard, the Israeli press is full of stories about how more and more native-born Israelis are not pushing themselves at all, and are evading army service. In the summer of 2007 an army report put the percentage of draft-aged Jewish youth getting out of their service for one reason or another at nearly twenty-five percent – either yeshiva students receiving yeshiva exemptions, or secular youth receiving medical or psychological deferments.

"Does this make you feel like a sucker?" Friedman is asked.

"No, but it kind of drives me nuts. I can't understand why there are so many people who live here who aren't going into the army, or into combat units. I don't understand that. It bothers me, especially because there are not enough people in combat positions. I can understand if someone is sick or injured, but people who are just trying to get out of it, I find that very difficult to understand.

"Being in the reconnaissance unit as a lone soldier is a huge plus," he says. "In the sayeret you work in small teams. These are guys you are with for three years in the army, and then throughout the reserves. The same guys. They really take care of me like a brother. I go to their houses all the times, I'll spend holidays with them, go to their homes for Friday night dinners. They take me out on weekends; we go to parties, stuff like that.

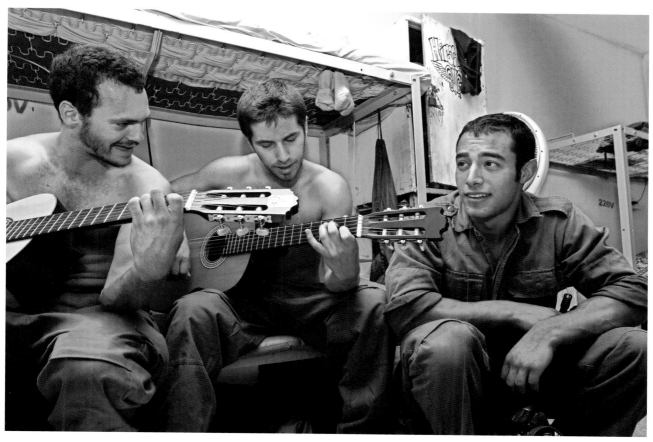

Friedman enjoys leisure time with other soldiers in his paratrooper unit.

"In the beginning it was a lot harder," he admits. "But I've been with them for two years already and have gotten very close to them. Some of the jokes and the cultural references I didn't get at first, but now that I've spent so much time with them, I get them."

For instance, Friedman says that when he used to sit down and watch a popular satirical show called *Eretz Nehederet* with the guys in his unit, they would crack up laughing, and he would sit there stone-faced. "I didn't know what was going on. Now I understand."

His Hebrew, learned in a Solomon Schechter school in the States but honed and fine-tuned in the army, is a constant source of jokes. "They laugh at my accent, it's a big joke. But there is nothing I can do about it. It's funny; I also laugh when I make mistakes."

But Friedman says acceptance, despite his accent, is not a problem. "They accept me totally, they love when I come over, they always bug me to come to their homes for the weekend."

This acceptance, so important in what can be a very lonely framework like the army, comes from living together, eating together, fighting together, going on missions together.

"When there isn't a war we pretty much go into the territories every night," Friedman says, describing his unit's daily routine. "We were in Jenin for a while, and are now probably going to move into Nablus. We go in and either gather information, capture terrorists or kill them. We go in pretty much every night. During the day we get our equipment ready, sleep, eat, and get ready for the night."

Those types of activities – carried out together, as a unit, day after day, night after night – remove barriers and level the playing field; even for those with accents, even for those who come from abroad.

CHAPTER 5

Kasaw Dtala

Ethiopia

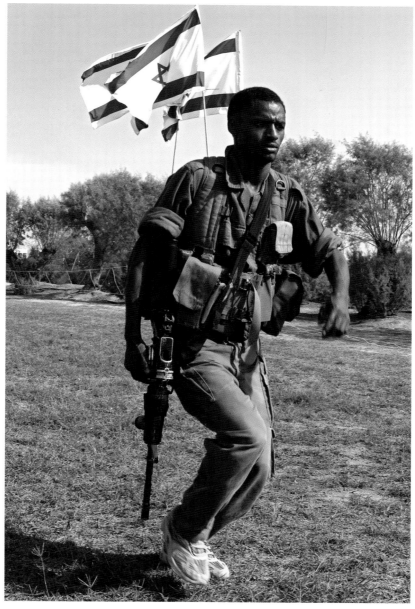

Kasaw Dtala competes in an IDF running competition.

Kibbutz Kinneret, on the southwestern tip of Lake Kinneret, epitomizes establishment, Labor Zionist Israel.

With the shimmering lake just down the road, the pink Golan Heights visible in the east, the verdant Galilee hills in the west, and the smell of pine trees in the air, this is the Israel romanticized in so many Hebrew songs – songs about trees and hills and working the land and orchard-scented, pastel afternoons.

Many of those songs were written by Naomi Shemer, who grew up on the eucalyptus-lined kibbutz and was inspired by its landscape, geography, and ideals. Shemer, who died in 2004, is buried just up the road in the Ohalo cemetery, which is also the final resting place of such Zionist luminaries as Rachel the poet, Moses Hess, and Berl Katznelson.

Kasaw Dtala, twenty-one, one of the newest arrivals at Kibbutz Kinneret, has never visited the cemetery, doesn't know where it is or who is buried there. Chances are he hasn't committed to memory many of the words of Naomi Shemer's songs, and hasn't heard of Moses Hess. Which isn't really all that surprising considering that Dtala, from a small village in the Gondar region of Ethiopia, didn't exactly receive a traditional Labor Zionist education.

Indeed, Dtala – who today serves in the Paratroopers' 202nd Battalion – received no formal education at all, at least not until he came to Israel at the age of fourteen. From when he was just five years old, Dtala lived in the fields near his village, guarding his family's flocks and produce. He was illiterate when he arrived in Israel, unable to read or write even in his native Amharic. Now he is literate in both Hebrew and Amharic, but his journey – like the journey of so many other Ethiopian Jews who have come here over the last two decades – has not been without enormous challenges and difficulties.

The Ethiopian immigration to Israel is a proud chapter in the country's history. But like all real-life chapters, it is not one-dimensional. It is not entirely the story of dedicated Jews, from loving, nuclear families, who came to Israel out of a deep yearning for Zion and were accepted with welcoming arms by their white brethren. The story is much, much more complicated, and Dtala reflects that complexity.

Although Dtala's parents – who were divorced long ago – do live in Israel, for purposes of getting assistance for housing he is recognized by the army as a lone soldier. Lone soldiers are not only immigrants from abroad who come to the country alone, but also include hardship cases of soldiers who for a variety of reasons don't have a home to go to when they get furloughs from the army.

"I didn't always live with my parents," Dtala says, beginning a narrative of a family life that is far different from what Western Jews have come to expect: mother, father – even if divorced – and a couple of kids.

"We lived in the field near our village," Dtala says. "Our parents were at home, and we were in the fields – I almost always lived away from my parents."

Dtala's parents were divorced not long after he was born, and his father moved to Israel soon thereafter. His parents had another son, who has since died. Both Dtala's parents remarried

and his family then ballooned, giving him a mother, father, stepmother, stepfather, fourteen half brothers and sisters and two stepsiblings. "It's fun," he says, "but not exactly a vacation."

In Ethiopia, his family owned some cows and fields of barley, which he and his brothers were charged with watching to keep thieves from plundering.

"Living in the fields is what we all did, all my friends as well," Dtala says. "In the summer there were no tents, and we slept on the ground. In the winter we put up tents. We were not afraid."

Dtala, now sitting in a small, self-contained room on the kibbutz that has a bed, two televisions, a sofa, refrigerator, burners, and sink, remembers the scenery in the Ethiopian fields as not that dissimilar from the view he has on his kibbutz near the Kinneret.

But he didn't know about the Kinneret in Ethiopia; all he knew about Israel was Jerusalem. "I first heard about Israel when I was very little," he says, and then corrects himself. "I didn't hear about Israel, only Jerusalem. Israel I learned about when I got here."

Dtala, whose father left him when he was just a baby, says he was told when he was five years old that his father had made aliya and gone to live in Jerusalem. "What a shame, I thought," Dtala remembers, "because I would always think about him, but could not see him."

His reunification with his father came years later, when – at the age of fourteen – Dtala came to Israel. The elder Dtala, who had settled in Haifa, went to meet his son at the absorption center in Beersheba. He also brought some of his children – Kasaw's half brothers and sisters – whom Kasaw had not previously met, and had only seen in photographs.

"They came to visit me," Dtala retells the story, with little visible emotion. "When I looked at my father and my brothers, I cried. They were big, and I was small. They grew, and I stayed small."

In fairy tales, or in movies, such a reunion often leads to a strong connection between father and son, regret for the past and a new closeness that can't be torn asunder. That's in the fairy tales.

In Dtala's real life, however, things were different. "I got a good feeling from this, but I didn't feel free either in my mother's home, or at my father's. I can't do whatever I want when I'm there, and I like to do what I want. That's what I like about living here on the kibbutz. I come home and can do what I want."

Dtala hasn't seen his father for the last three months, or his mother for almost half a year. "We don't talk that much," he says, in a definite understatement.

Dtala's journey to Israel began at the age of twelve, when his mother and stepfather bundled up the family and moved to the Jewish Agency compound in Gondar.

There the long, drawn-out process for permission to make aliya began: Identification pictures were taken and interviews about medical conditions were conducted. The family waited

in Gondar for three years, during which time Dtala went to live with an uncle in a nearby village.

His mother and stepfather didn't work during this period, and the family lived off the cows and produce of the field that they had sold before moving, and some money sent by Kasaw's father, who had found a job in a fish factory in Israel.

Asked why his family wanted to move to Israel, Dtala replies simply: "Because we are Jews. There the non-Jews told us to go to Israel."

Dtala says he felt hostility from the non-Jews, who "could tell from your face that you were a Jew. They didn't get along with me, and I didn't get along with them. I only had Jewish friends."

When the family finally received permission to make aliya, they went from Gondar to the Ethiopian capital of Addis Ababa and stayed in a Jewish Agency compound near the embassy. There they were given a two-week crash workshop on life in Israel.

"They taught us about behavior in Israel, and how it is a country of laws, that there is no need to fight or to hit," he remembers. "They gave lessons on how to raise children, and said things are done differently there."

These workshops also included films preparing them for life in Israel, films that told them about their rights as immigrants and introduced them to concepts such as stoves, refrigerators, toilets, and disposable diapers.

The future immigrants also learned some rudimentary Hebrew. They did not, however, learn much about the political situation in the country.

"They didn't talk about terrorism," he says. "I thought that everyone in Israel was Jewish. I learned a lot of things when I went into the army – about the non-Jews, the Arabs, the terrorists – that I didn't know in Ethiopia.

"When I was in Ethiopia I heard there was a war in Israel, and I knew that there was an army, but I didn't know much beyond that," he says. "I dreamed of joining the Paratroopers. I considered enlisting into the Ethiopian army at one point, but then I thought, 'I am a Jew, why enlist there?'"

Army recruitment in Ethiopia, Dtala points out, is vastly different than in Israel. "There the army takes you at a young age, it doesn't matter to them. They can take you at thirteen, as long as you are the right height. They took many Jews into the Ethiopian army by force. They didn't take me, but took a friend of mine. His parents paid some money and they eventually released him."

This friend was lucky. Many of those taken into the Ethiopian army are never heard from again. Some have been killed in the protracted war between Ethiopia and Somalia.

Dtala was attracted to the Paratroopers because he always dreamt of jumping out of an airplane, though he had never actually been on one until the day he flew from Addis to Tel Aviv.

That day he remembers fondly, and not only because it was his first plane ride. After

landing at Ben-Gurion Airport, the family was taken to an absorption center in Beersheba. "It was nice," he says. "There was a set schedule. We studied Hebrew and played a lot of soccer."

A short time later he was enrolled in a religious boarding school in a community called Yad Binyamin near Ashdod. Because most of the Ethiopian Jews are from traditional families, Israel's policy is to channel the Ethiopian immigrant children to the state religious school system.

"My father wanted me to be religious," Dtala says. "But I don't want to be, it is difficult for me to be religious in the army. It is difficult to observe Shabbat there."

Which doesn't mean he is without faith. "I believe in God, and follow Him. But you also need to be strong, and not only think that God will help you. If you make an effort on your own, God will help."

"We learned a lot of Torah," Dtala remembers about his two years at Yad Binyamin, where there was a group of some twenty-five Ethiopian immigrant boys. "We wore kippot and put on tefillin every day." Dtala learned to write Amharic and Hebrew there, and also spent a lot of time playing soccer, something that served as a bridge with the native-born Israelis at the school.

"I got along with everyone there," he says. "I'm able to get along in every place. My Hebrew wasn't great, but we would play a lot of soccer." Soccer has also served Dtala as a good entry card on the kibbutz, where he plays whenever he gets a chance.

It's Friday afternoon on the kibbutz, and a pre-Shabbat calm has descended there, giving it the easy feel reminiscent of an American Sunday morning. Dtala lives in a room that used to serve the kibbutz children, until they moved on to larger quarters. His small room is fronted by a bed of orange flowers.

The slightly built Dtala, who sports a closely cropped goatee, has just returned for Shabbat from serving with his unit on the northern border. He will go back to his border post Sunday morning. The first thing he did when he came home was take off his uniform and change into jeans and a T-shirt. His army boots were quickly replaced with much more comfortable sneakers.

Walking to the communal mess hall for lunch, a group of four youths sitting on the lawn calls out and ask him if he needs a challah for Shabbat. A younger boy sees him, asks if he will be playing soccer that afternoon, and claps him a high five. "I fit in here," Dtala says, adding that after the army he would like to remain on the kibbutz.

But "after the army" remains a long way off. Following his years at Yad Binyamin, Dtala – still enamored of the idea of jumping out of a plane and urged on by his father, who encouraged him to join a combat unit – tried out for the Paratroopers. He wanted to get into Duvdevan, one of the force's elite units and one with an excruciatingly demanding training period of nearly a year and a half.

Dtala gets somewhat annoyed when asked why he would try out for such a difficult army track when he has only been in the country a few years. "What difference does it make how many years I've been here?" he asks.

"I didn't have to join a combat unit, I could have become a jobnik," he adds, using a pejorative term for soldiers in non-combat roles. "There are a lot of people who don't do the army at all. But I worry about the state all the time. I don't know why. I'm worried that we could lose it. This country is good; it has given us a lot."

Dtala says his father impressed upon him this way of thinking. "My father always says 'thank you' for being able to come here. He doesn't lack anything. My mother doesn't work, but my father works in a factory. He doesn't have a good salary, but it's okay. He wanted me to enlist in a combat unit as well. He says we have to give to the state, that there is no place like it; that the people are good."

So try out for a combat unit Dtala did, and he admits to great disappointment and frustration that he did not get accepted into Duvdevan. "I was really upset," he recalls, saying his failure to get accepted was odd considering that he came in first in a number of drills during the two-day tryout.

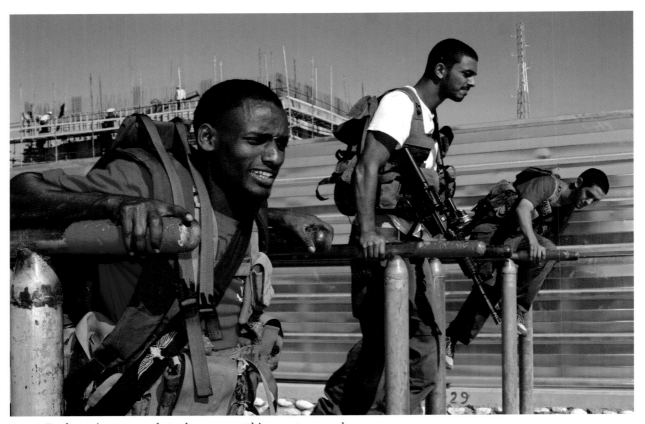

Dtala trains on an obstacle course at his paratrooper base.

In a land in which Ethiopian immigrants are sometimes the object of derogatory taunts and there are reports of discriminatory treatment, Dtala – touching on a sensitive subject – adds that his failure to get into the unit had nothing to do with his being black.

"The reason they didn't take me could have been because I have a complicated family situation, or because my Hebrew is not good enough. It is impossible to know, but it is not racism, it is not because I am Ethiopian," he says.

Dtala recalls a time when he was on a patrol in Hebron, and one of the Jews there – a kid of about fifteen – called him "*kushi*," a term that has taken on a derogatory meaning.

"My officer told him off," Dtala says. "He yelled at him, 'How dare you talk to him that way, when he is here protecting you – going without sleep and food?'

"Was the kid racist? I don't know. It could be that he was just stupid, that he didn't know the meaning of the word, that he didn't mean anything by it. I don't know. But this does not happen a lot."

Dtala says he has not felt any racism in his unit, and has not had a difficult time getting accepted by his fellow soldiers.

"I like the guys I'm with," he says of the forty-five men he now very much shares his life with. "I am fond of them, and they are fond of me. We have new immigrants in the unit from Russia, Colombia, South Africa, and we have another Ethiopian. The unit is good to me – if I need anything, they always help me out."

The other soldiers in Dtala's unit are constantly inviting him home for Shabbat, but he usually turns down the invitations, preferring instead to go back to the kibbutz and relax. "I'm basically shy," he says, stating the very obvious. "I connect well with them, but it is not that enjoyable for me to go home with them."

The invitations, however, do give him a sense of being wanted, a sense he says the country has given him as well. "If the country didn't want us here, it wouldn't let us come, or go into the army."

The army, he adds, was not that difficult for him to adjust to. "The most difficult part about basic training for most people is being told what to do, but that didn't bother me."

Ironically, the most difficult thing for Dtala since he has been mobilized – besides trying to understand army slang – is not his time in the army, but rather where to go when he has time off. The crowded homes of either of his divorced parents were never an attractive option.

"In the beginning I lived in a soldiers' hostel in Tel Aviv," Dtala says, adding that the arrangement was not good because of a lack of privacy. "The door to the hostel was open twenty-four hours a day, people were always coming in and going out, there was no privacy, nor a place where I could safely leave my stuff."

When that didn't work out, he asked his officers to arrange a room on a kibbutz. But when they were unable to do so, he was provided an apartment with a number of other Ethiopian soldiers.

"That wasn't good for me either," Dtala says. "In the end they got drunk and broke a door and we got kicked out. I told my officers that I wanted to leave the unit so I could find a job and have a normal place to live.

"They told me 'no,' that I was needed in the unit, that I was a good soldier and helped out a lot. They told me I was not going to be discharged. I liked the army, it was good for me, but I needed better living arrangements. I wanted to live alone."

His officers took the issue up with Dtala's brigade commander, and in the end he was told that something could be arranged.

"I waited for about two and a half months, and then this materialized," he says, making a sweeping motion with his hand around his room. "It is good for me here. I feel good, comfortable. I come home here and can sleep and relax. I'm here for three days, and it feels like I've been here a week. Believe me, that's very good, very important."

So good that he reiterates his desire to remain on the kibbutz when his army service is over. "I pray I can stay here after the army, learn a vocation and work. Please God I will have a good job, get married, and bring children into the world."

And those children – who will get the traditional Israeli education their father never received – will surely learn of the storied cemetery just up the road.

Maya Golan

United States

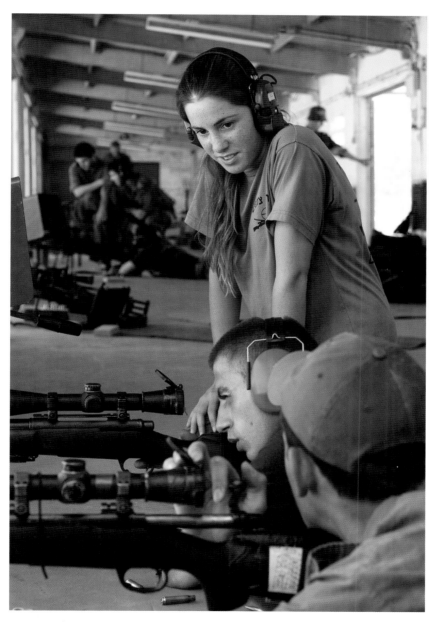

Maya Golan supervises sniper training exercises.

75

If one of Israel's two major theaters – Habimah or Cameri – were ever to put on a Hebrew-language revival of the 1946 Broadway musical *Annie Get Your Gun,* they could do much worse than consult with nineteen-year-old Maya Golan about the lead role of Annie Oakley.

Not because Golan has ever heard of Oakley or the musical based on her life, nor because she physically resembles the legendary female sharpshooter of the Wild West, nor because she can sing or act.

Rather, consulting Golan would be wise because – like Oakley – Golan can shoot, and does so extremely well. So well, in fact, that this petite and perky redhead sporting a green T-shirt with a rifle emblazoned on its front is teaching select Israeli soldiers how to be snipers.

Unlike Oakley, who started hunting when she was nine years old to help support her family, Golan came to guns much later in life – after she joined the IDF at the age of eighteen. Even then her dream was not to become a sniper, but rather an instructor, preferably an instructor teaching young Israeli recruits the art of navigation, or how to get from point A to point B without a map.

But after completing a combined two-month basic-training/how-to-be-an-infantry-instructor course, Golan was told she would be teaching how to shoot a balloon from 800 meters, rather than how to find one's way through the desert by moonlight.

"At first I was annoyed about it, but now I'm really happy with it, I mean, I like it," she says, sounding very much like the Middle American girl next door, precisely because she is the Middle American girl next door, albeit one who just happened to transplant herself to an army base between Tel Aviv and Jerusalem and take up teaching the fine art of picking off targets.

She is sitting just outside her army base, in a wooded area designed for parents who want to visit and picnic with their soldier children. The pop-pop-pop sound of guns going off at a firing range not far away is constantly in the background. Golan pays it no mind, as oblivious to the jolting rifle shots as she is to the delicate chirping of the birds on nearby trees. Birds chirping and guns firing is the ordinary sound track at this base.

"I shot pretty well during basic training," she says, explaining her path to becoming a senior instructor. "Not all those who shot well in basic got here. Getting posted here has to do more with your ability to be an instructor than your ability to shoot. If you are a good instructor, this is one of the better jobs you can land in the army – this and teaching navigation."

Golan, who was born in Israel to an American immigrant mother and an Israeli father, lived in Israel until she was eight, when the family decided to pick up and move to Rockford, Illinois, about ninety minutes north of Chicago. At seventeen she returned to live in Israel, and a year later entered the army as a lone soldier.

"I didn't want to join a fighting unit because I am not in very good shape," she says of the army options that were open to her. "There was one unit that I could have joined, a mixed unit of boys and girls, but all they do is twelve hours of guard duty a day, and man roadblocks – nothing ever happens. It's not very exciting. But in my job I have gotten to go to Gaza and actually do stuff that is more interesting."

The more interesting "stuff" includes the five-week sniper course she had to pass, with the army operating on the principle that you can't teach what you don't know. This track, she laughs, was not exactly her childhood dream. "I had no attraction to guns as a kid," she says. "I was always afraid of shooting."

That fear of shooting, in fact, carried over with her into the snipers' course. "I hated the shooting at first. I hated the noise. But then you get used to it. Now I like it – just grabbing a gun, trying to get a good wind read on it. Listen, hitting a target at first shot from 800 meters is not the easiest thing to do.

"There are all kinds of factors involved in shooting," she explains. "The wind and how you breathe and how you stand and the temperature and humidity and everything. You can go through a million things. You even have to take into consideration the spin of the earth if you shoot over 1,000 meters."

She talks about how difficult it is to shoot a 50-millimeter Beretta, and how her favorite gun is a standard 25-millimeter sniper rifle. She talks of this as if they were the most natural topics of conversation for a nineteen-year-old woman.

The course was fascinating, she says. "We learned the basics of shooting: long-distance shooting, moving targets, camouflage, how to go into a house, urban warfare, everything. I know everything about it now – which is what I like about the job, it is very varied."

As varied, and wide-ranging, as it all may be, it is completely different – in all respects – from what her friends are doing back in Rockford, friends she met up with a few months ago when she went back for a month-long visit.

"It was nice, but kind of boring at some point being at home for a whole month," she says. "I met up with my friends, and we took some road trips in the area. We went to Minnesota."

Inevitably, they compared notes. "They are all in college, or working. When I told them I was teaching guys how to shoot, they were like, 'That's pretty cool.' They didn't have much to say other than that. They don't really understand. Then they would ask, in hushed tones, 'Did you kill anyone?'"

And that was the reaction of her girlfriends.

The boys, she says, reacted in a similar manner, but with a somewhat different twist. "They thought it was really cool. They loved it, and were saying things like, 'Don't mess with her.'"

This, to a certain extent, was also the reaction of some US marines she has trained in Israel, always surprised to see a female shooting instructor.

During her eighteen months in the army, Golan has trained marine snipers on two different occasions. "They loved it," she says, repeating a favorite phrase. "They actually learned quite a bit. We had a commander of one of their sniping courses, and I was amazed at some of the

basic knowledge he didn't have." The marines, she says, come to Israel for training because "at some point they understood that we kind of work differently."

According to Golan, one of the main differences between the way Israeli and American snipers train is that "we take books and learn about all the numbers and calculations, how to figure everything out – the mathematics."

Another difference is the less rigid atmosphere of the Israeli military, something that takes the marines some getting used to. "It is hard for them at first," she says. "It's like, 'Wow, you don't have to talk to your officers in a special way, or call them sir.'"

The only difficulty she had with the marines was translating the Hebrew gun-speak into language they could understand. "At first it was tough translating all the professional terminology into English. How am I supposed to know what a bolt action rifle is in English? I usually teach all of this in Hebrew – gun parts, targets and target sizes, how to direct the soldiers through the targets. Doing that in English took some getting used to."

Golan denies that her gender, relatively small size, and her American background pose any problems when she teaches either the marines or the Israeli recruits. After all, with the Israelis – at least – she is their sergeant.

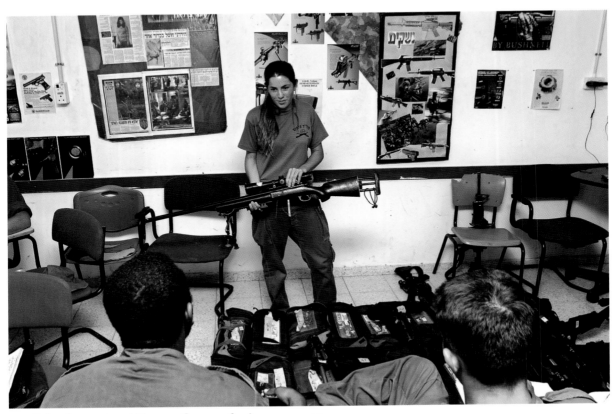

Golan instructs soldiers on the use of sniper weapons.

"I'm their commander," she says. "Commanders tell their soldiers what to do. They listen to me as they do to a man, they don't make a distinction. They don't belittle me. They know that I know a lot more than they do. I'm pretty comfortable. I definitely shoot better than they do, at least during the first couple of weeks of the course."

Sniping actually runs in the family, though Golan didn't realize that before she was well ensconced in her shooting course. Her father, the artist Roni Golan, served for a period as a sniper in a special forces unit, but Maya – typical for a nineteen-year-old relating to her father's past – is not overly impressed.

"He was a sniper with an old gun," she says, with a somewhat deprecating air. "Things were different back then, and he wasn't a fighter that long."

Golan's father and her mother, originally from the Chicago area, met at Tel Aviv University shortly after her mother made aliya. "My mom came on aliya when she was eighteen, she came alone – the same thing I did."

The young couple had two daughters in Israel – Maya and Yasmin, who is a year older – and moved to the US when Maya was eight. They moved, Maya says, because there were simply more job opportunities in the US for abstract artists like her father.

That Golan has decided to come back to Israel illustrates the revolving-door nature of Israeli society: Some leave, more come, and often the children of those who left are the ones who come back. The door keeps turning.

Ironically, leaving Israel was more difficult for Golan's American-born mother than her Sabra father, partly – she explains – because her mother had lived in America, and decided at a certain point in her life that was not what she wanted.

"She loved living here – remember, she moved here – and didn't like living in the States," Golan says. "She still wants to move back all the time, and they have been working on that for quite a while. Eventually I'm sure they will come back, I'm just not sure when."

Golan has no enduring, lasting impressions of her first eight years in Israel, a period during which the family moved around quite a bit to different kibbutzim and moshavim. She does, however, remember her initial thrill at moving to the US.

"I was excited because everything was going to be new," she remembers. "It was like going on vacation for the first time. New food, a new house – and a house much bigger than the one we had over here."

She had never been to the US before her family transplanted her, and her first impressions of the country of which she heard so much were Oreos and Fritos. "My mom bought snacks on the way from the airport. I was so excited we had a new car, and all the food. Everything was exciting."

But, of course, it wore off, and as so often happens in the frigid winters of the Midwest, the snow is what first took the shine off. "The first two winters were great and exciting, and

then after that it was normal, and then in the seventh and eighth grade, I was like, 'enough already.'"

The family moved from a country where the rhythm of life is innately Jewish to a metropolitan city of some 350,000 people, of whom just 1,000 were Jews, half of them not practicing. She went to a Reform Sunday school that had ten students – in all the grades – maybe twenty during a good year. "I hated going to Sunday school because it was at a low level. They would even have me teach Hebrew lessons, and my Hebrew wasn't that good at that point."

In "regular" school she felt "a little different, but not bad."

"I would tell my friends about Israel, and they would be like, 'All right, enough already.' It's not like in Israel where everyone sits on the edge when you tell them you are from the States and they ask you a million questions."

Nevertheless, Golan fit in, and never felt like an outcast. During the summers she would return each year to Israel with her family to visit her grandparents, including her mother's parents who had made aliya. It was during one of those trips, when she was going into eleventh grade, that she decided she wanted to stay.

"It was all very spontaneous," she remembers. "I was just talking to a friend of the family, and I decided, 'that's it, I'm staying.'"

At the time she was just shy of fifteen years old. "I guess it was because I felt more comfortable, I don't know. I told my folks I'd stay wherever, but I had to stay."

Her parents were more concerned with the practicalities of where she would stay, and with whom, than anything else. Though it was 2003, the height of the Palestinian violence known as the Second Intifada, concerns of security were not an issue.

"My parents know Israel," she says, dismissing the security worries. "It is not like it is a lot more dangerous than the school shootings and stuff in the States. I wasn't afraid."

But she was weary of Rockford. "I was sick of the school," she says, adding that she had, and still has, good friends there.

"It's just that when I got to Israel I went out to a few parties and realized there is a life here, that people don't just sit in their houses all day and watch movies and have house parties. There was something more exciting here. Rockford is very boring, there is nothing for kids to do. I hate sitting inside watching TV all day. I was looking for something a little more exciting."

In Israel she definitely found something more exciting, or at least different. Rather than the familiar locker-lined halls of her high school in Rockford, Golan lived in a youth house on Kibbutz Gvaram, just north of the Gaza Strip where her parents had lived for a short period when she was young, and went to a nearby regional school.

Language, obviously, was a struggle. "My Hebrew was horrible. I knew how to spell 'mom,' 'dad,' and 'house.' That was it, but somehow I managed to scratch by. I had an amazing year, and decided I wanted to go back to the States, finish high school early, and come back."

She says she just clicked with the country during that year. "I realized there was so much

more to do here," she says. "I liked the people and made a lot of good friends. My friends in the States sit and stare at each other. I don't know what they do. They watch TV, and go to college and drink all day, and that's their life, and that's not what I wanted to do."

So she returned to the US, finished her studies, packed up, and returned on aliya – all before her eighteenth birthday. Her friends in the States – ninety-nine percent of whom were not Jewish – struggled to understand what she was doing.

"They had no clue. I mean, you can tell people, but they couldn't really understand."

Golan, with her sister Yasmin, celebrates her grandparents' fiftieth wedding anniversary.

When she arrived in Israel, Golan enrolled in a program called Shnat Sherut, a year of voluntary community service a growing number of Israeli teens do before going into the army. She joined a group from the Israeli Scouts in Afula, providing programming for Ethiopian youths and young people from disadvantaged homes. She also served as a teacher's aide in the schools, giving kids struggling with their schoolwork some individualized tutoring.

The group of pre-army youth she was with – six girls and two boys – lived in a rented flat in Afula, and because of a meager budget subsisted for the year mostly on hot dogs and french fries. "They took me in just like that," she says. "They were great; there was no problem with being accepted."

From there she hooked onto another program, one that feeds into the army, called Garin Tzabar. This program was originally set up to help children of Israelis living abroad come back to Israel, but is now open to all immigrants. It provides a kibbutz framework for groups of lone soldiers going into the army, and includes four months on a kibbutz before the army, including an ulpan, which Golan did not need, and then accommodations on the kibbutz during the duration of the IDF service.

The members of each group do not serve in the IDF together, but do live together on the kibbutz. Golan's kibbutz is Sasa, about a mile from the Lebanese border in the Upper Galilee. Her sister, who is also a lone soldier, is a member of another Garin Tzabar group that lives in a kibbutz just down the road.

"She is a lot less enthused than I am," Maya says of her sister. "She has a boyfriend in the States – a long-distance relationship. It's not easy."

Asked whether it helps or hurts to have a boyfriend while in the army, Golan quips, "it depends what kind of boyfriend, and whether he gets out [of the army] a lot."

Golan, for her part, gets out every Shabbat, one of the perks of her job. But most of the other members of her Garin Tzabar group – made up of thirteen girls and twelve boys – are not as fortunate, meaning the group is not as cohesive as it could be, simply because they don't see each other that much. Half the group are children of Israelis, and while most come from the US, the others come from Britain, France, Colombia, Austria, and Ireland.

Though Golan could have gone into the army alone, she preferred the organized framework this program provided. "The kibbutz has a person in charge, who makes sure everything runs smoothly while we are in the army. It's just all a lot easier."

While some of those in her group want to make aliya after completing their army service, others just want to serve in the IDF and then return to their countries of origin. "They want to serve in the military, serve the country somehow," she says. "Its part of their Zionist ethos."

As for Golan's preference?

"When I get out I want to do what everybody else does – travel, preferably to South America. Then I want to come back and study, though I'm not sure exactly what. I want to stay here. I have a lot of good ties to the country now, friends and places that I'm familiar with. I also have an adopted family in Sasa that I'm very close to. I just like it here."

Anton Tsarkov
Russia

Anton Tsarkov on a combat mission in the West Bank.

The people, the sun, and the vistas: Those are the elements Anton Tsarkov fell in love with when he first arrived in Israel from Russia two years ago, just short of his eighteenth birthday. That is what set Israel apart from his native Russia, a place he never liked: a dark, cold, Dostoyevskian Russia without smiles, imbued with alcohol and crime; a Russia he had wanted to flee since he was a young boy.

The story of the immigration of Russian Jews to Israel is epic and well documented. It's the story of how a small group of Jewish activists – the Sylvia Zalmansons, Yosef Mendeleviches,

Ida Nudels, Yosef Beguns, and Natan Sharanskys – kept Judaism alive in the Soviet Union at an enormous cost to themselves and their families.

It's the story of a movement that galvanized Jews from all over the world who pleaded and protested and lobbied and demonstrated until the Iron Curtain melted and the Soviet Jews poured into Israel by the tens of thousands.

Some one million immigrants from the former Soviet Union moved to Israel between 1990 and 2008, making up fully one-seventh of the country's population. They filled the ranks of the high-tech sector, they swelled the population of doctors and engineers, they packed the orchestras, they went into the army in huge numbers: They changed the face of the country.

They also included an estimated 350,000 people who are not halachically Jewish, meaning they do not have a Jewish mother. Many of these people don't have a Jewish father, either, and were eligible to immigrate because under Israel's Law of Return anyone with one Jewish grandparent is eligible for citizenship.

Tsarkov is one of those. His grandfather on his mother's side was Jewish – one Haskel Aharonovitch, formerly of the Red Army. That's the extent of Tsarkov's Jewish connection.

Tsarkov grew up in Tutaev, a town of some 80,000, three hours from Moscow. He grew up knowing absolutely nothing of either Judaism or Israel. Nothing. He says he was taught there were three great religions: Judaism, Christianity, and Islam – and that was the breadth of his religious upbringing.

Born in 1988, he also heard nothing of the glory days of the Soviet Jewry dissident movement, and even today the names Slepak, Edelstein, and Butman draw a complete blank. It's all unknown history for him, still undiscovered waters.

Tsarkov, while not halachically Jewish, considers himself a Jew – a common phenomenon among the non-Jewish Russians who have lived in Israel for any significant amount of time and want to remain. But in Tsarkov's case his self-definition is a bit problematic, because he believes in Jesus.

Welcome to Israel, circa 2008.

Tsarkov, incidentally, is also what is known in Israeli army lingo as a "*spitz*": a great soldier, a top fighter. He wears a number of pins on his uniform: one that indicates he is in one of the Paratroopers' elite reconnaissance units, one that shows that he successfully completed his parachute training jumps, and one – a gold one – showing he was designated the top soldier in his unit. And Tsarkov's unit is a top unit.

Ironically, Tsarkov says he had no religion when he arrived at Ben-Gurion Airport, and only became religious in Israel – but it was not the predominant religion of the country.

"My mother was messianic in Russia," Tsarkov explains. "We had big problems at home – my father drank. When things get difficult you look for something, and she found Jesus. That really helped her."

A short while after immigrating to Israel in 2004, just before joining the army, Tsarkov had problems with a Russian-born girlfriend he met here.

Where does that feeling come from, he is asked.

"I think from God," he answers. "I think that every Jew in the world feels that his first homeland is Israel, because God gave it to him."

When reminded that he is not a Jew, he says, "It's the people, I love the people."

He also likes the military. "Everything," he says again, when asked for the specifics. "The food, the Zionism, but firstly, my unit."

His unit is an eclectic mix of people: religious and secular, a French soldier, one from the US, an Ethiopian immigrant, a Beduin. "We are all together," he says. "We imitate each other's accents."

Tsarkov doesn't play down the difficulty of the army, but says that difficulty is easier to cope with amid the realization that it is simply something that needs to be done, that the country's borders need to be protected. The physical difficulty, he adds, is manageable. "In the beginning it is hard, but not now, not after the training. They teach you not to feel the difficulty."

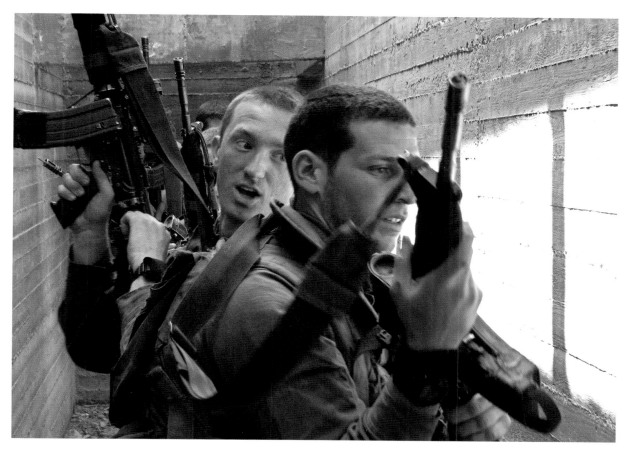

Tsarkov trains with his elite paratrooper unit.

Tsarkov is toying with the idea of an officers' training course, and has already done a four-week snipers' course – also graduating with that course's designation as "best soldier."

"They say that I was a good shot in training, and sent me to the course," he says. "I don't relish having to kill anyone. In the final analysis it is not fun to have to kill people, terrorists or not. I never met anyone who said, 'Wow, it is fun to kill.' But sometimes that is what needs to be done."

Tsarkov, who lives on Kibbutz Yiftach in the Jezreel Valley, says the life he is leading now is completely different from anything he imagined for himself when he was growing up in Russia. So different, that it is impossible for him to convey it to his acquaintances in Russia, acquaintances he visited on a trip back home some fourteen months after his induction.

"I didn't tell people what I do in the army," he says of that visit, paid for by the IDF. "They knew I was in the army, that was enough."

His reluctance to talk had to do both with a concern about giving away military information, as well as a realization that those he spoke to in Russia had no idea of what he was going through. "There's no point in talking about it," he says. "They thought it was strange when I decided to come here."

His mother, however, does understand him, and he speaks to her weekly. "I call her every Friday, and am trying to convince her to move here. The time has come."

In the meantime he sends much of the NIS 2,000 salary he draws each month back to her in Tutaev. Life for his mother in Russia, says the combat soldier who fought in the Gaza Strip in the winter of 2009 and sporadically goes on missions deep inside the West Bank, "is much more difficult."

Michael Levin

United States

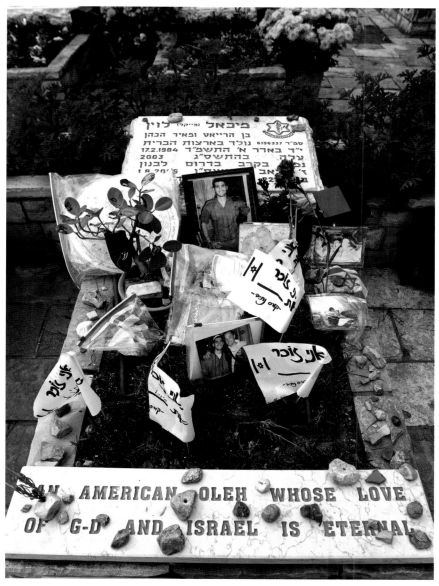

Grave of Michael Levin on Yom Hazikaron, Israel's National Memorial Day for the Fallen.

Of the 119 IDF soldiers killed in the 2006 Second Lebanon War, two names have been seared into the Jewish collective memory.

One is Lt.-Col. Ro'i Klein, commander of the Golani Brigade's 51st battalion, who was killed when he fell on a grenade thrown at his troops during a battle in the Lebanese town of Bint J'beil. By falling on the grenade, and using his body to absorb its blast, Klein, thirty-one, married with two small children, saved the lives of his fellow soldiers.

This story – understandably – touched the nation profoundly, and Israel honored Klein posthumously by bestowing upon him its highest honor, the Medal of Valor, given to only forty people since the creation of the state. Soldiers in his unit said that Klein threw himself on the grenade while saying the *Shema Yisrael* prayer.

The other soldier is St.-Sgt. Michael Levin, twenty-two, a 118-pound American lone soldier with a wide and infectious smile, who was killed by sniper fire during a battle with Hezbollah near the village of Aita al-Shaab in southern Lebanon on August 1, 2006.

Levin, from a Philadelphia suburb, was one of five lone soldiers killed during the war. Whereas Klein's story touched people because of the selfless way in which he died, Levin's story touched both Israelis and Diaspora Jews deeply because of the choices he made while he was alive.

For instance, Levin's decision to move to Israel right after high school without any family; his decision to press to get into a front-line combat unit; his decision to cut short his vacation to Philadelphia in July 2006 to fight in the Second Lebanon War; his decision to ceaselessly nudge his commanders to make sure that he would not be left out of the fighting in Lebanon.

"What is it about Michael, about his story, that touched the hearts and minds of so many people?" Mark Levin, Michael's father, says a day before attending a memorial ceremony in Jerusalem marking a year since Michael's death, repeating a question he is frequently asked.

"Was it the fact that he was a lone soldier, and he did not have to do any of this, that he did not have to go in the army but did so voluntarily? Certainly, that's a part of it.

"Was it the fact that he was so small in size – he was 5'6", 118 pounds after he ate – but went out among hundreds and hundreds of people who tried out for the Paratroopers and was one of the few they took at the end? Probably. It is almost a paradigm for Israel – so small yet able to overcome so much and triumph over so many. That certainly is a reason.

"Was it because he had the courage of his convictions? Obviously. I think that people are drawn to his story because he went and did what he said he was going to do, even though it was not an easy task. So few people actually do that."

Whatever the reason, there is no doubt that Levin touched a nerve. His funeral, held on a scorching fast day in August – Tisha B'Av, commemorating the destruction of the First and Second Temples – drew thousands. His memorial service drew hundreds. And his grave draws dozens of people each day, including groups of American youth who stop there for a lesson on Zionism and heroism.

One of those who bring groups to the grave is Yossi Katz, a Jewish history teacher at the

Alexander Muss High School in Israel and one of Levin's teachers when he was on a two-month program there in 2001.

Katz, who taught Jewish heroes to Levin, now teaches Levin as a Jewish hero. The classroom in Hod HaSharon where Katz teaches, adorned with pictures of Jewish heroes like Hannah Szenes, David Ben-Gurion, and Menachem Begin, now has a corner where pictures of one of those who sat in those seats and looked up at that very same gallery of Jewish heroes are now displayed prominently.

"When I teach, I focus my course mostly on heroism," Katz says. "In every period of Jewish history I try to give the students Jewish heroes and heroines they can look up to. Heroes and heroines spoke to Michael. He was very emotional and touched by these stories. A lot of times kids are touched, and that's it. But you could tell that things were different with him – what touched his heart he then translated into actions, he translated them into deeds in his life."

Katz remembers that Levin was especially affected by the story of Yonatan (Yoni) Netanyahu, the commander of the Entebbe raid who was killed while freeing Israeli hostages in a raid on Uganda's airport in 1976. Levin is now buried a few rows down from Netanyahu at Jerusalem's Mount Herzl military cemetery.

"As the course went on we read more and more letters from Yoni's book, *Self-Portrait of a Hero: From the Letters of Jonathan Netanyahu*," says Katz. "In one letter he writes his father to explain why he was leaving Harvard to rejoin the army. He said that he could not tell his friends to re-enlist for more IDF duty, and then not do so himself.

"I made a big lesson with the kids about how important it is to do the things they believe in," Katz says. "I said that if you don't believe in Shabbat, don't keep Shabbat. If you don't believe in kashrut, don't keep kashrut. The problem is not in doing things we don't believe in, the problem is that there are so many things that we do believe in, but then don't find the strength and courage to act on them. That is the test of character."

This lesson, Katz says, touched Michael deeply. "He felt in his heart that Israel was the place where the Jews should be, and that if young Jews were standing and fighting to defend the Jewish people, then he should be there as well. And I think he felt like Yoni Netanyahu – if that is what be believed, then that is how he should act."

And he did.

Levin came to the Alexander Muss High School in Israel program when he was in eleventh grade, and then – immediately after high school – he returned to Israel for a year-long leadership course called Nativ. At the age of sixteen, sitting in Philadelphia, he decided he wanted to move to Israel and join the army, and after the Nativ program he did just that. Levin pushed hard to get into a combat unit, and was killed while in the Paratroopers 890 Battalion on an operation during the Second Lebanon War. Two other soldiers were killed in that battle.

Katz says that Michael wanted to serve so fiercely that he decided to go into the army even before he received a draft notice. He went to the induction center near Tel Aviv to enlist without his papers, and when he was informed that he could not be processed or even get through the

front door without them, he pushed a dumpster up against an outside wall and climbed into the building through a side window.

"After going through the assembly line where new soldiers get their uniforms and shots, he entered a room where an officer asked for his papers," Katz says. "After Michael said that he didn't have any, the man said nobody gets through the front door without papers. Michael's response was, 'What makes you think I came through the front door?'"

After that, Katz says, "the guy took Michael aside and said, 'You know how many people I deal with who do everything to try to get out of here, you are the first person I've ever dealt with who broke in to get into the army.' He then helped Michael get his papers."

Levin's motivation was unstoppable, noticed, and appreciated.

"I remember talking to one of the generals who came to Michael's funeral," Mark says. "We were talking about Israel's fighting spirit, and I said that if the army had 100,000 soldiers like Michael, with his spirit and love for the country and Zionism, then the IDF would be invincible. He looked at me and said, '50,000.'"

Levin grew up in Holland, Bucks County, Pennsylvania, in a committed Conservative Jewish household. He had two sisters, an older sister, Elisa, and a twin, Dara. Israel was important to his family and his parents visited numerous times, but they never talked of moving there. He didn't go to a Jewish day school, but rather to an afternoon Hebrew school. Every summer he went to a Ramah camp in the Poconos.

"He grew up playing street hockey and baseball, but he loved Israel," his father says, trying to explain the evolution of his son's attachment to Israel. "I think part of it was that Michael was just born with a Zionistic soul."

Part of the power of Michael's story, at least to American youth, is his very American normalcy, the everyman nature of his upbringing, even a streak of naive chutzpah.

During Pessah of 2006, Michael was taken for an outing with other lone soldiers to a hotel in Tel Aviv, where he saw Shimon Peres, who was then deputy prime minister in Ehud Olmert's government. "Michael went up to Peres and said, 'Excuse me, sir, I want to introduce myself. My name is Michael Levin,'" Mark says with a chuckle. "I want you to remember that name; I'm going to be famous some day.' When he told me this story, I said, 'Michael, what are you doing, you don't just go up to these people and say something like that.' And he just laughed and said, 'Dad, you are going to have trust me on this one.'"

A documentary of Levin's life called *A Hero in Heaven* that was shown on an Israeli television channel on Remembrance Day for Fallen Soldiers, and later distributed around the world, shows some pictures from the family album: his bar mitzvah, summer camp photos. These are pictures, Katz says, that American Jewish youth can relate to.

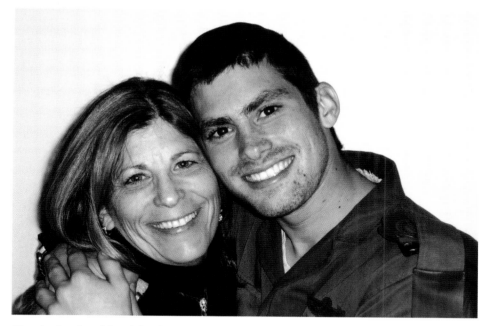

Harriet Levin with Michael in uniform.

Levin with his sisters Elisa (left) and Dara at a July 2006 wedding in the US. Michael returned to Israel immediately afterward to fight in the Second Lebanon War in which he was killed.

"When American Jewish kids see the film, they don't see an Israeli in a *ma'abara* [1950s transit camp]. They see something they can relate to; they can say, 'I have a bar mitzvah picture with a candle lighting ceremony just like that, I have a picture with a baseball helmet at summer camp.' That is what pulls American kids in – the thought that, 'Wait a minute, here is someone like me, and look what he did.'

"Israelis produce superheroes of a different kind," says Katz. "American kids can be touched by [Yom Kippur War hero] Avigdor Kahalani or Yoni Netanyahu, but they are from somewhere else. Michael was American. He had his Phillies hat on, he loved Tastykakes. They can relate to him because he was just like them."

Israelis are pulled in to his story because at a subliminal level it reminds them of what they are doing here, what they are fighting for. "Michael struck a nerve in the Israeli populace," Mark offers. "I think I understand it now, because of the thousands of e-mails we got. We were getting 300 e-mails a day after the documentary aired. Israelis wrote saying that our son was teaching them about Zionism."

After the battle in which Michael was killed, his comrades went through his vest and found a small Israeli flag folded up in his pocket.

"That is what Israel meant to Michael," Mark says. "This was on the documentary and it really hit a lot of the Israelis who take Zionism for granted now, or have forgotten it. Here was this kid from America who knows and feels this stuff, who practices it every day. They say, 'We should be doing that, we should be teaching that to our kids.'"

Another element about the story that impressed so many was that Michael was on a furlough in the US when the war broke out; he didn't have to rush back to a war zone, but did so naturally, without any hesitation.

Michael's mother, Harriet, remembers that Michael didn't receive any phone calls from his officers entreating him to return, but just knew he had to come back. "There was no indecision, no need to explain," she says.

As to whether they tried to discourage him, Mark replies, "the thought never crossed my mind. Maybe it should have. I never once thought about saying, 'Why don't you cool your heels for a while? There's a war going on, wait a while and then go back, it will be safer.' I didn't even think about saying that."

Once he returned to Israel in July, Levin first had to fight his own commanders to be able to join his unit in Lebanon. He missed his unit's critical briefing and preparations before crossing the border, and was told that as a result he would not be able to go to Lebanon and instead was to go to Hebron to keep an eye on the unit's equipment there.

Michael's reply, according to his father, was simple: "You go to Hebron. I'm going to Lebanon." He made dozens of phone calls, pulled all the strings he could, and in the end got permission to join his unit in the war.

Harriet remembers that the day before he left the US to return to Israel, the two of them went to New York and saw a Broadway play. "He said that things were getting crazy in Israel,

and that he was going back to a war. He said that if something happened to him he wanted to be buried on Mount Herzl."

While driving his son to the airport, Mark remembers Michael's words: "Don't worry about me, I'm doing exactly what I want to do – going exactly to where I want to go."

After he was killed, Mark and Harriet had a brief discussion about where to bury him, and decided to honor his wishes. "It's the best thing we ever did," Harriet says.

Why?

"There are hundreds and hundreds of people visiting him, people come to his grave every single day. If you go to Mount Herzl, to his grave, it looks like a flea market. Somewhere between a flea market and a sidewalk sale. The other graves are pristine and beautiful, and Michael's has mementos and letters from everywhere, and *siddurim* [prayer books] and baseball hats and everything imaginable."

"If we had brought him back to the States, I would visit before Shabbat," she says. "But in the wintertime you can't go at all, it's too cold. In Israel he stands for so much more."

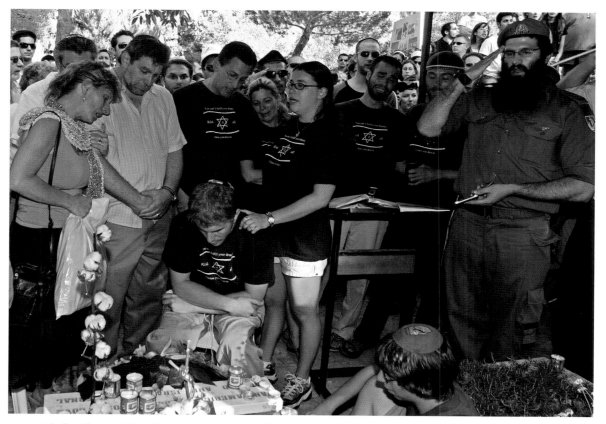

Levin's family and friends at a ceremony at his grave on the first anniversary of his death.

At the end of the Nativ program, the participants produced a yearbook. Levin put in a picture of an Israeli flag with the saying: "You can't fulfill your dreams unless you dare risk it all." That slogan was printed on T-shirts worn by friends at a memorial service at Levin's grave on the first anniversary of his death.

"That was his quote," Katz says. "Michael didn't have a death wish, he wanted to live more than anybody. He was full of life. When you look at him he was always smiling, full of life. But he didn't want to live a life that was meaningless. For him life was only meaningful, only worth living, if there was something you were willing to give your life for. And for Michael, that was Israel."

Mark says his son liked the army, so much so that he was interested in becoming a career officer, something he was, however, not sure would pan out. "Whenever I asked him how it was, how he liked the army, he would say it was 'great.' He never really articulated why he liked it so much. But I think it had to do with the importance of what he was doing. His unit went on a lot of operations, they stopped a lot of terrorist raids, they did a lot of good."

Michael was a history buff, and Mark says the two of them spoke long and often about both American and Jewish history. Michael's paternal grandfather was a decorated World War II veteran who fought in the Pacific, and his maternal grandparents were Holocaust survivors.

"We would talk about what his two grandfathers went through in the Second World War," Mark said. "So he had a really good sense of our place in the world – who he was, where he came from."

Though Michael never met his paternal grandfather, after whom he was named, he did have a close relationship with his maternal grandparents. They both survived Auschwitz.

One of the most difficult chores Harriet had to perform after her son's death was telling her eighty-four-year-old mother that her grandson had been killed in Lebanon.

"She was the hardest person for me to have to tell," Harriet remembers. "It was harder than even telling my husband.

"My mother was always very over-protective, because she lost everybody in the Holocaust. So she was always afraid of something happening to us, myself and my brother. She didn't want Michael to go, and I knew I would be blamed for it because I never tried to stop him. It was very difficult for her; she kind of went into shock. She reverted to speaking Yiddish, wasn't speaking English. You can understand, it was her sense of losing everything all over again."

Michael's grandmother did not speak about her Holocaust experiences with Michael, but his grandfather did – and at length.

"My father had a tremendous impact on Michael," Harriet says. "He passed away four years ago and he really affected Michael a lot. Perhaps more than I knew."

Just how much became heart-wrenchingly clear when Harriet came to Israel in April 2007, on the first Remembrance Day after Michael's death. In addition to visiting her son's grave, she also went to his old army base and spoke with his friends and officers. One of them brought out his foot locker.

"He wrote 'Zeide' on it," Harriet says, "and alongside were my father's numbers from Auschwitz. He painted my father's Auschwitz numbers on his locker."

Yoni Cooper

United States

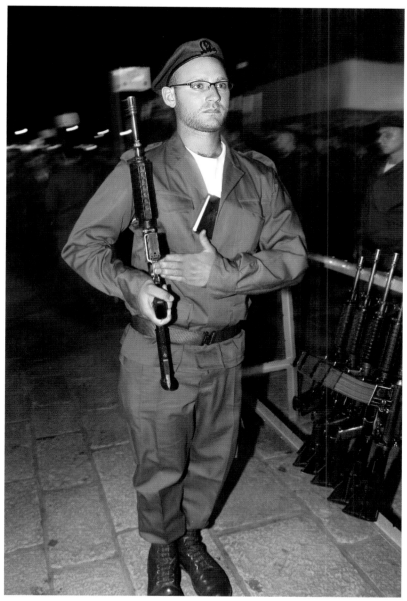

Yoni Cooper receives a gun and a Bible at his paratrooper swearing-in ceremony at the Western Wall.

"I count time differently these days," says Yoni Cooper, a twenty-four-year-old Philadelphia native, after spending two months in the basic training of an elite paratroopers unit. "I view the world differently now."

As well he should.

A year ago, Cooper – a modestly built man with short-cropped reddish-blond hair, and a closely shaven beard – was sitting behind a desk staring at a computer in the air-conditioned office of the American Israel Public Affairs Committee (AIPAC) in Los Angeles, drumming up political support for Israel.

Now, as he puts it, he has his nose "five centimeters in the mud, crawling through fields of thorns," defending Israel up close, with his body.

And his body aches.

"My knees are hurting," says Cooper, sitting in shorts and sandals in a Jerusalem coffee shop, just off the bus for a thirty-six-hour Shabbat furlough. "I don't know what's happened, but I feel I have old people's knees right now, ever since my first tryout with the paratroopers."

At AIPAC Cooper didn't work much with his knees; in the army he does. And he feels them. His world – the world he chose to join – is indeed a vastly different one than what he left.

As assistant director of AIPAC's LA office, Cooper rubbed shoulders with the well-oiled and conversed with the politically connected. His world at the paratroop training base near Kiryat Gat is more limited, much more restricted.

"I'm twenty-four," he says, stating facts, not complaining. "Right now I'm serving with eighteen-year-olds. My immediate superior is a twenty-year-old. The guy above him is twenty-one, maybe twenty-two. The head of my whole unit is twenty-four. He's my age. It's bizarre."

Equally bizarre, some say, is the fact that Cooper, with a BA in international relations and Judaic studies and an interesting, decent-paying job in LA, picked up, left his comfortable surroundings in December 2006 and opted for two years of knee-aching, life-risking duty in the IDF.

"Without fail, when people in the army hear my story, someone will ask me, 'Are you crazy?'"

"What do you reply?"

"Yes, a little bit. But I don't have another country. This is my country. I have to serve."

Well… yes, and no. As a new immigrant, it is his country. But he chose to make it so; he chose to serve. The way Cooper explains it, however, the choice was self-evident.

Cooper, whose father is a Conservative rabbi in a suburban Philadelphia synagogue, grew up with a zeal and deep commitment for Israel. He went to Israel on a number of occasions as a kid, and spent his junior year of college – he attended SUNY-Binghamton – studying at the Hebrew University in Jerusalem.

"I always thought about living in Israel," he says. "I remember telling myself that I wanted Israeli kids, not American ones. That I wanted Sabras. I always thought I would come here at

some point, that I would spend a big part of my life here. Aliya was always on my mind, I thought about it seriously when I graduated, but it just wasn't the right time."

Instead, he went to work for AIPAC. But then Michael Levin, a childhood acquaintance, someone Cooper went to camp with for seven years, was killed serving in the IDF during the Second Lebanon War in 2006, and everything changed.

"I was working in LA for AIPAC, doing great work, feeling that I was helping Israel. But after Michael's death I felt useless. I knew intellectually that I was helping Israel down the road, ensuring diplomatic support, a strong Congress, ensuring that people voted in Congress the right way. But I felt uncomfortable sitting in a suit and tie in my office, when I had a friend fight and die and defend Israel with his body. I didn't feel good about it, and pretty much immediately knew that I had to go serve.

"I felt awful during the war. I felt that I just needed to be in Israel. I felt like I had – God forbid – a parent, sibling, or close friend in the hospital, and that I was somewhere else and couldn't be by their side."

Levin's death, Cooper says, affected him much more than he had anticipated. Levin wasn't one of his closest friends, and he wasn't the first person Cooper knew who had died.

"But he was killed fighting for Israel," he says. "That really had an effect on me. At first I felt I needed to take his place, but I kind of pulled back on that. I can't take his place. His place is forever his place, but I can walk in his footsteps, I can follow his lead."

Though Cooper is only twenty-four, his decision was based largely on a concern about how he would look at himself in old age. "I don't want to wake up when I'm eighty or ninety years old and say to myself, 'You know, there was something sixty years ago that I could have done to help Israel, but I didn't.' To wake up one day and have that thought would be awful."

Any further residual doubts melted away after a chance conversation during the war.

"There was a briefing at the home of Ehud Danoch, Israel's consul-general in LA, during the fighting," Cooper says. "It was packed, and I remember talking to some of his security guards, Israeli guys after the army, and I spoke about wanting to be in Israel."

"I was struck by their response. It was so simple. 'Go. Why don't you go? Why don't you go in the army?'

"I said, 'Well, I'm working for AIPAC.' They said, 'Go. If you really want to help, go. Go to Israel and serve.'"

Cooper heeded their advice, and five months later landed in Israel, ending up at Kibbutz Ein Tzurim in the Jordan Valley and pushing hard to be included in the March draft.

At first this seemed impossible – there wasn't enough time to get onto the books for that draft – but his persistence paid off, and the day before the tryout for the Paratroops he was

called and said that he could come to a *gibush* (tryout) being held the next day for new immigrants and lone soldiers.

"It was Purim in Jerusalem, and I was half drunk when I got the call. Some guy introduced himself as Shachar, and said that if I still wanted to do the *gibush*, I had to be at Tel Hashomer [a large base near Tel Aviv] at 8:30 in the morning, twelve hours later. He said that he knew this was an important decision, and that I could have twenty minutes to call my parents."

Cooper reached his folks, and his father – who had earlier presented his son with all the reasons why he should think twice about going into the army – advised him to jump at the chance.

"My dad said, 'Are you crazy? This is the opportunity you've been waiting for. This is something you've been talking about for five months. Are you going to miss the opportunity?'"

Eleven hours later, after taking leave of his girlfriend of a few months – a girl he would later marry while still in the army – he was at Tel Hashomer scampering up and down hills with sandbags on his shoulders.

Cooper is physically not imposing. He is of average build, with neither arms nor chest bulging through his shirt. Indeed, his most striking feature is pale blue eyes, not generally a sign of a daunting physical presence.

Yet, he has proven fit enough to make it into one of the army's crack units.

"I'm in okay shape," he says. "I worked hard in the fields on the kibbutz for a couple of months. I had a shirt-and-tie job in the States, and not much time to work out. But, as they say, it's all in your head, everything is mental.

"There are really strong guys in the *gibush* who didn't do as well as I did, and there are weaker guys who surpassed me. It's not about the strength. Once you get to a basic level, where you can run two kilometers in eight or nine minutes, which isn't that fast, then they want to see if you have the heart. Because after carrying that sandbag on your shoulder for an hour and a half, no matter who you are, it's going to hurt."

At a certain point, he says, everyone asks themselves if it's worth it.

"I didn't think it would happen to me," he admits, "but after forty-five minutes with the sandbag I asked myself what I was doing there. I said I could just drop the sandbag and forget it. I don't need this – I could get a cozy job in the army for six months, do my mandatory duty, and that's it."

"It takes a strong mind to say, 'Remember why you are here, stick with it, it is going to be worth it in the end.' This is something that I'm going to have to remember though basic training and through the entire service. I still think to myself sometimes, 'Why am I doing this?' I have a girlfriend, but I'm not with her. I'm in the field. I'm hot, I'm hurting, what am I doing this for? I have to remind myself why I'm here."

"What's the answer?" he is asked.

"Its like when the Jews were in the desert and were given the Torah," he says. "First they followed their heart, they said *na'aseh* (we will do), then they said *nishma* (we will hear). First

the heart, then the intellect. I'm following my heart, and my mind will understand later. My mind is telling me that it hurts, stop, that this is not good for my body. But my heart tells me to continue, that this is the right thing to do, that it will all be worth it later."

As difficult as the physical aspect of the service is, that isn't the hardest part – that distinction goes to loneliness.

"I don't really fit in," Cooper says. "I'm kind of an outsider. I'm an American, I'm twenty-four, I don't have much to talk to the guys in my unit about. They are talking on their cellphones and listening to their music, and I'm reading Michael Walzer's book *Arguing About War*. I'm loving it, and the kids are looking over and saying, 'Why are you reading that?' I look around and see that I'm the only person reading."

Ironically, he says, those he would most like to become friends with –those closest to his age and with his intellectual curiosity – are his officers, yet they are out of bounds. At this early point in his army career "you just don't speak to them," he explains.

Although Cooper speaks Hebrew, and speaks it well, the fact that it is not his mother tongue also creates a barrier – a barrier that any immigrant in any country can attest to.

"It's hard. You don't only have to know Hebrew, you have to know army Hebrew. Abbreviations. It's a whole different language. And even with regular Hebrew its tough enough. It's hard to express myself, and that's another part of feeling lonely.

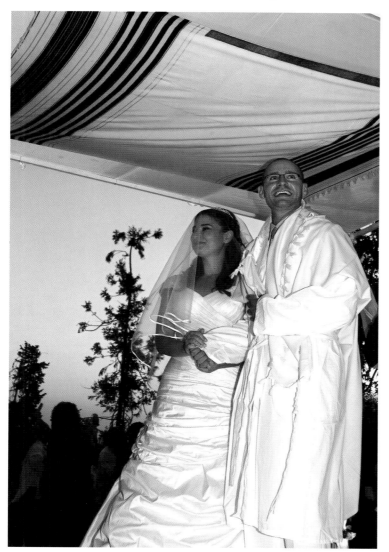

Cooper marries Eliana Schonwald, another Israeli-American, during a short furlough from his army service.

"I have given up trying to express myself deeply in Hebrew. Language is a large part of who I am. I'm used to writing philosophy papers, and choosing my words very carefully. But here I'm forced to use the same verbs over and over again. It's tough."

Cooper says he is still trying to figure out how to deal with the loneliness.

"I try to find things to appreciate," he says. "Like the flowers. In the middle of the desert, you'll find that one flower. Focus on the flower. You have to, you have to find things to appreciate, or you'll be miserable."

The army, ironically, also gives him plenty of time for thought. There is little free time – he gets about an hour a day for himself during which he generally showers and runs up part of a $200 a month cellphone bill – but, thanks to hours of guard duty, there is plenty of time to think.

"You start thinking about a lot of things you normally don't have time to think about," he says. "I think a lot about God, and the past, future, present. I think about time, and how you measure time. It's right now very hard to live in the present, because I'm always looking into the future. But for the next two years I will be serving, and that's it. I want to be able to try and enjoy this time, because if I constantly only look to the future, I'll be miserable."

"But you're in the army," he is asked, "what's to enjoy?"

"There's always something to enjoy."

Pressed for examples, Cooper pauses for a moment and says "Yom Hashoah" (Holocaust Memorial Day). Realizing the irony of that reply – one doesn't exactly "enjoy" Yom Hashoah – he recasts his thought.

"Okay, so I won't say enjoy," he explains. "I'll say there is always something to appreciate. On Yom Hashoah there was a ceremony on the base, but I had to do guard duty. I was annoyed, because this was my first Yom Hashoah in the army, and I wanted to go to that ceremony.

"So there I was, and the sun was setting, and Yom Hashoah was coming, and I realized, 'Wow, what a merit I have to be one of six people guarding the Paratroopers' base, one of the best units in the Israeli army, which is one of the best armies in the world.

"'I'm guarding this country with an M-16 in my hand, commemorating people who didn't have an army, didn't have M-16s, who died because they couldn't defend themselves. And now I can defend this base, while the rest of the base can enjoy a ceremony, and while the rest of the country can commemorate the lives of people who were slaughtered in the Holocaust.'"

Other things, more mundane, that Cooper appreciates are the food – "It's great, really, they say that after the air force, the food at our base is the best in the army" – and the treatment he has received from his officers.

"They definitely have sensitivity to the fact that I am older, and a lone soldier," he says. "I think it is a new thing. I don't think it was always that way. Now they go out of their way to make us feel welcome. At our induction ceremony at the Kotel [Western Wall], they had a special ceremony for lone soldiers where they gave us food. The head of the Paratroopers training base came and spoke to all of us. Tzvika Levy was there, presented us with gifts.

"They give us special furloughs once in a while, and once a month they give us a day to run errands. I'll be moving into a new apartment in Jerusalem next Friday, and I'll get out for that. One of my officers heard that I found an apartment, and asked if I needed anybody to come help me move. 'You have a whole military team here at your disposable to move your stuff,' he said. 'First things first. Let's get you settled in; you definitely need a place to stay.'"

Yet, he says, the officers also treat him – despite his age and background – like any other soldier. And it's not always easy being any other soldier.

Cooper had no Rambo images of the military before he arrived, and says he was never attracted to the machismo of the army or of fighting. Rather, his was a decision motivated solely by doing what he thought he needed to do as a Jew.

"I never fired a gun before I came here, and never wanted to. In fact, I never touched a gun or had any interest in guns. I was never into guns or military stuff. I never had any of the Rambo in me.

"In fact, one of the things that scares me, almost as much as dying, is having to kill someone. But if I have to kill someone, I'll kill someone. If I have to kill a terrorist, knowing that he wants to kill me, kill the people I love, destroy the country I love, then I will."

Which doesn't mean he isn't afraid. He is, and admits it readily.

"Yeah, I'm afraid," he replies without hesitation, when asked about fear point blank. "I cried on Memorial Day. I was really scared. I thought about dying. I thought, 'I'm serving in a unit where when I finish my training I will be put into situations where people want to kill me. And my friend died doing just that.'

"Yeah, I'm scared. But I have faith in my officers to train me. It's hard right now to think that within a year I'll be ready and trained as a soldier to defend the country. It's a lot of pressure, a lot people have fought hard and died for this country."

Cooper looks out the window of the coffee shop located near downtown Jerusalem, at the road that leads to the Old City and near where the boundary of the capital ran before the Six Day War. It's a Friday afternoon, a few hours before Shabbat, and the city has begun to slow down. "We're sitting here on Road No. 1, and right here paratroopers died in 1967," he says. "They died for me, and I'm taking their place, and I could die. I try not to think about it. But I'm ready to die, if that's what needs to happen, that's what needs to happen. But am I scared? Sure I'm scared."

That fear, however, doesn't mean he thinks he made a horrible life-choice mistake.

"I haven't regretted my decision once," he says. "There are times that I'm hurting; times that I'm sad and lonely.

"I wanted to make aliya, and I made aliya. I wanted to be a paratrooper, and I'm a paratrooper. I wanted to be in an elite unit, and I'm in an elite unit. I wanted to be healthy, and – thank God – I'm still healthy. I'm happy, I've gotten everything I've asked for. I'm doing what I know is right."

"'Forget it,' I'll say, 'let's just drink another beer and have some laughs.'"

So they drink another beer, and they laugh, and they keep the army, and politics, at a comfortable distance – wise policy, considering that Belgium has been extremely critical of Israeli policies over the past decade. But there Mermelstein is, still very European, still in a pub, still with his Belgian friends, yet still a soldier in the Israeli army. It's a delicate balancing act.

Mermelstein on a night out with friends in Belgium.

"I don't get into politics with them," he says. "When they bring it up, I'll just say, 'forget about it.'

"I don't even want to talk about politics with Jews who don't live in Israel – people like my father's friends. When they talk about it, I tell them to leave me alone, that they don't live in Israel, that they can't say what the country should and should not be doing. They don't have a say. It's like people who watch a soccer game, and say 'he should have passed to the left,' or 'he should have passed to the right.' They are watching at home on the television, they don't see everything, and don't know what they are talking about. It's all nonsense."

Mermelstein doesn't fit the mold of the lone soldier from western Europe or North America. He did not study in Jewish schools, does not have Israeli parents, is not religious, is not propelled

by a great ideological fervor and – for that matter – doesn't even consider himself a Zionist.

"I'm not a Zionist," he insists. "I simply think this is something that a Jew needs to do. I don't observe Shabbat, I don't keep kosher. Nothing. This is what I do."

His interest in the army, his willingness to put his life on the line for a state he was not born in, stems from trips his family made when he was a child.

"I used to come here a lot when I was a kid," he says, "My mother is Austrian, my father is Belgian. Both are Jews. We would come here as a family for Pessah and Shavuot, or just to visit. As a kid I saw the guns everywhere, and the soldiers, and there was something very exciting about it. When you are a kid you only think about action, that is what is on your mind. At sixteen I decided I wanted to go into the army."

Mermelstein says the urge to join the IDF "left me for a while, but came back when I was nineteen or twenty – I was a bad kid, and thought that if I went into the army it would straighten me out." He says it was always clear that the army he would join would be the IDF, not the Belgian one. "I feel myself more Jewish than Belgian," he explains.

Mermelstein, fidgeting with a scab on his forearm, wasn't overly keen on elaborating what he meant by "being a bad kid."

"I did a lot of nonsense, but that was in the past," he says with a half smile, adding that he never got in trouble with the law. "I did not behave as I should have. The army was a good place to straighten out." This is a conclusion he reached on his own; no one told him, "Go into the IDF, it will be good for you."

"All my life I wanted to contribute to the state," he says. As to the source of this feeling, Mermelstein just shrugs his shoulders. "I don't know. I always felt a connection to Israel. It comes from the Jewish soul, no? I think that every Jew has a connection to Israel, even if he has never been here."

At a certain point he decided that the time had come to act. "I thought, 'OK, this is the time to contribute – I am young, and the best thing I can do is to go into the army when I am young.' I told myself that this was good for the country, and that it was good for me too. There are people who contribute money, others who plant trees, and others who make aliya. I said I would come here and do a year and two months in the army and that would be my contribution. That became two years and four months, which has now turned into three years."

Mermelstein's decision to do twenty-eight months, instead of fourteen, came about because he wanted to get into an elite unit, and to do that he had to sign up for additional time. His decision to add on yet another eight months stemmed from wanting to serve the full time like the rest of his comrades in his unit.

"I have been with these guys since my first day in the army. When you are with them for so long, when you live with them, fight alongside them, you develop a close bond. I decided to stay with them until the end."

Mermelstein says that while at the beginning of his service he felt that he had a distinctly different outlook than his Israeli comrades, now the gaps have narrowed.

"Look at me, I talk with my hands, I talk like an Israeli. With time you forget where you came from and look only at the present. I am a soldier, I live on Kibbutz Ginossar. True, I came from Belgium, but now I am a soldier here."

His acculturation, however, was not without hiccups.

"There is still a bit of a culture shock," he says. "Israeli manners are horrible – horrible. They don't give things back, they don't close doors, don't wash their cups after they drink, they don't clean up after themselves. That's true of the people in general, and in the army it's only worse, because the guys come here and don't have their parents standing over them telling them what to do. All you have over your head is the officer, and he is only concerned about how you fight, not whether you are neat or how you behave around the table."

Sitting on a little wooden bench in a makeshift park outside his base, a park strewn with empty plastic soda bottles, sunflower seed shells, and potato chip bags, Mermelstein found this difference in manners difficult to cope with at first.

"With time I overcame the cultural gap – I became a bit more Israeli, and I pulled the guys in my unit a little bit in my direction. They know I am very pedantic. They know that if they take something from me that they have to return it."

Thirty-two months into his service, Mermelstein's comrades still call him *Belgi*, the Belgian. But despite the nickname, a constant reminder that he is different, Mermelstein feels he has integrated.

"They know that I do everything that they do, that I am going to be in the army as long as they are. They can't say to me that I'm different because I'm doing a shorter stint. I'm doing three years just like them."

"Does it bother you when they call you 'the Belgian'?" he is asked.

"It did once, but not now. You build up a defense mechanism. It's like when you are a kid, people laugh at you and you start to cry, but then you get over it. This is just a nickname, it's not something they call me because they are laughing at me, or making fun of me."

Indeed, Mermelstein feels the other soldiers in his unit respect him for volunteering to serve. In fact, he says he's tired of people praising him for a decision he feels is so natural, "no big deal," but rather a Jewish given.

"When people in the army hear that I'm from Belgium, they inevitably say two things," Mermelstein says. "The first is, 'Mathieu, good for you for coming to the army. *Kol hakavod*.' They say that all the time. In fact, I'm sick of hearing it. I don't want to hear it anymore. Okay, I am here. Thanks. Let's move on.

"The second thing they ask me is why I'm doing this. What am I doing here? Don't I have a life? When I say I want to contribute to the state, they say, 'But you are not even from here, get out of here.' When I say again that I believe volunteering is good for you, that it is good for the karma, that it all comes back to you in the end, they say, 'Good for you for coming to the army, Mathieu, *kol hakavod*.'"

Mermelstein's culture shock was compounded by another shock all new recruits experience – the shock of confronting an army life that is far different than expected.

If he was attracted by the action, what he did not expect was the cold splash of water that awaited him when he first set foot in Michveh Elon.

"We were given uniforms, guns, the whole lot," he says of the pre-basic training course at the Galilee base for lone soldiers and new immigrants. "You learn what the army is, how they speak, what the ranks are. All the things that the Israelis already know because they live here; because they have brothers and fathers who tell them everything. They made us run a lot, and it was physically more demanding than basic training."

But the physical aspect was not the only difficulty.

"Beforehand you don't really know what the army is. You have an idea, but you don't really know. You live in Belgium; you do whatever you want. Then you come here and wear this uniform all day, and run and run and run.

"There were people from all walks of life – rich and poor, religious and secular, weird and normal. There was really a multicultural clash. It was difficult. People didn't understand each other, they screamed at each other. By the end of the three weeks it all worked out, but it was difficult."

The pre-basic training made his four months of basic training easier, because he knew what to expect. "The problem in basic was that it was just too long. They dragged it on. What is basic training? It is to take a civilian and turn him into a soldier, to get him into the mentality of the army. After that there is further training, and that is when soldiers are turned into fighters."

Mermelstein's further training was long, over a year, and grueling. But it didn't diminish his appetite for action, an appetite he still retains. "The adrenalin remains high," he says.

The army, obviously, is not only action, and for every fighter out on a mission, there are others at the base guarding or performing the more mundane logistical jobs. He doesn't want any part of that.

"My job is to be a fighting machine," he says. " Not to sit on guard duty. That is my job. If there is a mission, I should be on it."

Though his terminology, "fighting machine," conjures up romanticized action-movie heroes, Mermelstein says he isn't trying to be a superhero, and has no illusions about what the army is. But still, he says, "using the gun, knowing what to do if attacked; these are things that you learn, that are drummed into your head. Open the gun, load the gun, deal with a weapon failure – this stuff becomes part of you over time. You naturally want to use what you learn."

Asked whether he enjoys the missions, enjoys the tension, the action, Mermelstein answers positively, without any hesitation at all.

"Everyone in these types of units enjoys that," he says. "You volunteer to be in these units.

You don't have to be in a combat unit. You volunteer, it is harder, more pressure, more danger. I don't enjoy taking people out – I am not bloodthirsty, but that is our job. We do what we have to do."

One of the things that Mermelstein had to do in the summer of 2006 was spend a few weeks fighting in the Second Lebanon War.

"It was fun and not fun," he says, somewhat oddly, saying his entire unit was in Lebanon, primarily in two small villages. "Luckily no one fell in our unit.

"When I went into the army I never thought I would be in a war, especially not in Lebanon. No one did. We [the IDF] left Lebanon in 2000. Who thought we would have to return?"

Mermelstein admits he had no idea of what to expect in war. "I didn't know what war would look like, how it would go. I was never in a war before, and didn't know anything. You get there, and you just do what you were taught. You put all your thoughts to the side, and then when, finally, you take over a house and get some cover, you can begin to think about the things you put to the side. But until you get that cover, you only think about moving forward. That's it.

"The fighting is obviously unpleasant," he says, not elaborating. "In the West Bank we go after them, in Lebanon they came after us. It is more difficult.

"But there is something about sitting in a house with your unit, laughing and thinking about the types of things that you never would have thought about before. I started to write, because I had many thoughts and no one to share them with. I started a diary, writing about what happened that day, what would be tomorrow – all my thoughts. That's the type of thing I never thought I would ever do."

One of his obvious thoughts was how he, the son of a businessman and cosmetician from Antwerp, ended up fighting Hezbollah in a small southern Lebanese village. "A couple of times I thought, 'What on earth am I doing here?' But then I had another thought, 'This is my unit. I went into the army with these guys. I will do everything with them and for them. We will finish the job.'"

CHAPTER 11

Aiala Gisela Jinkis
Argentina

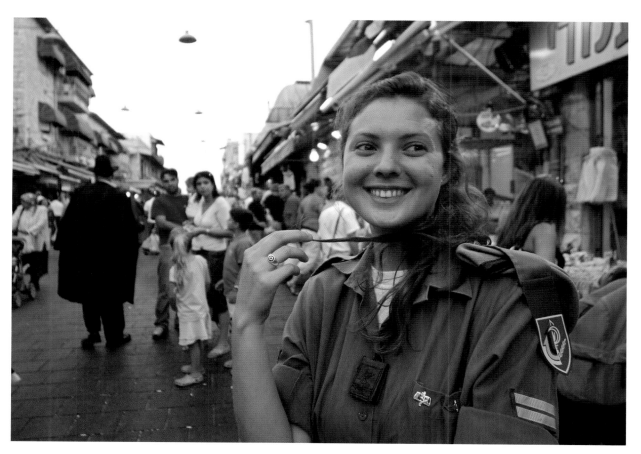

Aiala Gisela Jinkis enjoys the atmosphere in Jerusalem's Mahaneh Yehuda market during a Shabbat break from her army service.

If you tripped over the two large backpacks and trendy Zara shopping bag that twenty-one-year old Aiala Gisela Jinkis plunked down in the aisle of a busy coffee shop at Jerusalem's Central Bus Station one May morning, she would appear – sitting there in her army uniform, her hair in a long braid – as just another female soldier traveling to or from her army base.

That impression would be reinforced watching her swap a high-pitched *"ma inyanim?"* ("how's it going?"), followed by kisses on both cheeks, with a group of four women soldiers entering the café.

Jinkis, with brown hair and matching brown eyes, looks a natural part of the Israeli scenery. Physically she appears to completely fit in. No one is going to walk up to her, mistake her for a tourist, and start asking questions in English, French, or Spanish.

But they could, especially in Spanish. Because while Jinkis in uniform looks like someone who could be featured in a photo essay on the "new Israeli woman," the Argentinean native has actually only been in the country a little more than a year and a half, and is struggling mightily, as most new immigrants do, with the emotional challenge of trying to adapt to her adopted land.

Jinkis, who added the Hebrew first name Aiala to her given name Gisela after she arrived because "they sound similar," and also because Aiala sounds a bit Latino, is in the process of adjusting to the Israeli mentality, a mentality considerably different from that of her native country.

It is also a mentality that she does not have the luxury of slowly nibbling on at her own pace, like someone at a buffet, leisurely tasting different foods and taking time between dishes to savor it all. Rather, by virtue of the fact that she is in the army, that quintessential Israeli institution, she has had to swallow the mentality whole.

"Once someone here asked me if I feel Israeli," Jinkis says in a sing-song, Spanish-accented Hebrew. "What is it to feel Israeli? I am Argentinean. I lived there for nineteen years. In my heart there is Argentinean culture, and there is no reason to lose that. I am happy with that."

Yet when she was in her native Buenos Aires, she felt different – Jewish – from the time she was seven years old. Indeed, it was that difference that propelled her to Israel – a country whose language she didn't speak, and a land upon which she had never laid eyes until she arrived a week after the Second Lebanon War, declared herself a new immigrant, and approached a stranger at the airport holding a sign saying "Gisela" waiting to take her to an Ashkelon absorption center.

"We didn't speak the entire time," she says. "I had a stone in my heart. All kinds of feelings were going through my head, like 'What am I doing here?' 'How will I manage?' 'How will I learn Hebrew?'"

And therein lies the topsy-turvy emotional landscape upon which so many new immigrants tread: never feeling as if they quite fit in where they were born; never feeling as if they quite fit in where they have chosen to live.

"From the time I was a little girl I wanted to know what Israel was like," says Jinkis, who comes from a family in which no one had ever even visited Zion.

"My mother is Jewish now, she converted," Jinkis says. "The minute she met my father she said she wanted to convert to Judaism, even before they were married. She loves it. She thought it was the religion she wanted for her children." Aiala has a younger brother and an older sister.

Almost inexplicably, Jinkis says Israel was "always in my head. I think I got it from my grandmother, who used to read me letters she had from relatives in Poland before the Holocaust. I wanted to know what it was like then, to return to that – my family essentially came from there." Jinkis's great-grandparents immigrated to Argentina from Poland before World War II.

The sepia pictures of prewar life in Poland, the romanticized tales of a warm, cozy Jewish life there, seemed to trigger a yearning in Jinkis to return to that, or to where – logically – she felt that had been transferred: Israel. She certainly didn't find it in Buenos Aires.

"To tell you the truth, when I was in Argentina there were only three other Jews in my whole high school. You feel it; you feel you are a Jew. The Jewish schools in Argentina cost a lot of money. There is an excellent school, but my father couldn't afford it. So I didn't go. It was expensive, not like in Israel."

Jinkis says that although she remembers as a kid once being called a "dirty Jew," and another time accused by a classmate of killing his god, the prevalent sentiment she encountered was not one of blatant anti-Semitism, but rather that she was different because she looked at things differently from her friends. Whenever she would do or say something that diverted from her peers' group-think, they would say, "Yeah, you think that way because you are Jewish."

All this, she says, led to a degree of discomfort. "I didn't want that. I wanted to feel a part of something, where people understand what I mean. I always thought about coming to Israel, it was always in my heart: to live as a Jew, to go to Israel and see what it is."

Though she had never been to the Jewish state, Jinkis entertained the idea of attending high school in Israel, an idea nixed by her mother, who was fearful her daughter would not return, and was not willing to give her up at the age of fourteen.

"She was right. It is hard, it is hard for her now. She told me, 'I don't want you to go; I know if you go, you won't be coming back.'"

So Jinkis stayed in Argentina, completed high school, and began university as a law student at the University of Buenos Aires, the top-rated university in the country. But her heart wasn't in it.

"I signed up for law, but my head was here," Jinkis said. "At a certain point in time I said, 'Aiala, you have to stop, make aliya, see what it is like, and then after that, what will be, will be. But stop doing something you don't like.'"

She approached Jewish Agency emissaries in Buenos Aires and said she wanted to go to Israel, not as a tourist or as part of a Birthright program for a couple of weeks, but rather to see what it was *really* like, to immerse herself in Israeli life, to get intimately familiar with the mentality, the people, the soldiers. To jump in.

"I wanted to enter life here, so that afterwards I could say, 'Okay, now I know what it is like, is this for me?'"

The Jewish Agency, Jinkis says, did not give her many options beyond making aliya, and within a short time she did just that.

But when she arrived in August 2006, toward the end of the Second Lebanon War, the Israel of her dreams – of her overly romanticized dreams – clashed mightily with the noisy, dirty, often impolite, difficult-to-understand, and harsh reality that she faced.

"When I made aliya I got a shock, because I saw something else. I expected something different; I asked myself, 'What is happening here?' It wasn't what they told me. What happened? This isn't what I expected, what I thought.

"You always think before making aliya that Israel will be different from everywhere else. I don't know what, exactly, but different.

"But Israel is like any other country in the world. There is a difference here; I'm not saying there isn't. There is a feeling at times that we are all in it together, a feeling that doesn't exist in Argentina. But it is also a country that slowly is taking things from the US, becoming more and more like Europe."

Like so many immigrants, the Israel of Jinkis's imagination was placed high, on an unrealistic pedestal. Her arrival toppled it off that pedestal, and as a result her first steps over the shards were painful.

"I had to get used to the culture," she says. "It is different, Israel is not Argentina. I came here soon after the war in Lebanon, I lived in Ashkelon during a tough period. Everything was still the war. It was a real shock."

But it was not only the war, it was also not being able to communicate at all, not knowing the food, not being able to read signs or packages in the supermarket, not understanding what was being said on the radio, being alone for the first time, having to manage a budget, albeit a budget augmented by money the state gives its new immigrants.

"When I landed I was given NIS 1,000," Jinkis says. "In Argentina that is a lot of money. I thought, 'hey, this is fun.' The money is to help you initially set up. But I was eighteen years old and didn't always understand how to manage my money, so instead of buying food with the money, I bought a blouse."

One learns, she says, but the learning process is not always easy, especially since it entails a considerable drop in living standards, from a home with a car and television, to a small room with a roommate, a tiny kitchenette and a little bathroom. "It was a shock, completely different from what I knew," she says.

And then there is the complete, utter loneliness. "I did not appreciate my mother. I loved her, but did not appreciate her enough, I took her for granted. But when I came here I understood how important it was to have family, because I didn't have it. To wake up in the morning, see your father go to work, give him a hug and say you will talk when he comes back – I don't have that.

"I cried here," she says, "I feel my family will always be in my heart, but they are not with me. It's like death: you don't have anything, no mother, no father... you are alone."

In the beginning, Jinkis says, her parents were upset at her decision to leave. "When I started the whole process they said, 'What are you doing, why are you going, why don't you try your own country? What is the matter with you?' They always knew I wanted to make aliya. I always said to my mother, 'Mom, next year I'll be in Israel, you should know that.' And she would say, 'Okay, finish school.' I finished school, and she said, 'Okay, finish university.' I said, 'Mom, I'm going on aliya, I am going.'"

Her parents kept pushing off dealing with the reality that their child wanted to leave, hoping that something would intervene to keep it from happening. And when that "something" didn't arrive, they weren't emotionally ready.

"My mother said, 'What am I, a bad mother? Why do you want to go and struggle?' They were angry, and feeling a loss."

With the passage of time, however, they have come "slowly, slowly to understand that I am okay, that I like it here. They understand more now. But they always want me to return. My mother likes it when I'm happy, she wants that, but a mother always wants to be with her daughter. She always says to me, 'know that there is a university here that you can attend.'"

But rather than return to the university in Argentina, Jinkis stuck it out at an ulpan in Ashkelon, mastered Hebrew to the point where she felt she could "communicate what I feel," and fought the bureaucracy to quickly enter the army.

"When I was in the ulpan I felt that I was missing something, that I needed to go into the army to understand the mentality, know what was really happening in the country."

But, ironically for a country that is chronically short on military manpower, the IDF was less eager to accept her than she was excited to join. At twenty she was already two years older than most other girls entering the service, and not fluent in the language. The feeling she got from the army when she made her first inquiries was simple: "What does she want from us?"

Which is not a completely illegitimate question. Jinkis, who says she was always fascinated by how differently people look at the army in Israel than in Argentina, saw service as a vehicle to better understanding the state.

"You know that if you are in the army in Israel people are not looking at you like you are some unfortunate, some misfit who can't make it anywhere else, or someone who doesn't have any money. It is different here; people go into the army because they want to give to the state, not because they can't do anything else."

Finally, after letters, persistence, and badgering, the IDF agreed to take her. And, like so many new immigrants, she was sent by way of introduction to Michveh Elon.

"That was a real shock," she says. "It was basic training. They make you do all kinds of nonsensical stuff, like going from one place to another for no reason. It's not physically difficult, but it is mentally difficult. I'm looking at my officer and thinking, 'Who is she? She is younger than me. Who is she to tell me what I can and cannot do?'"

Socially it was also a challenge, because almost her entire group were immigrants from the former Soviet Union. There was also a French girl with whom she quickly became friends, and another South American woman in another group on the base. "I didn't understand Russian, so it was tough. It's funny, during that period I learned more Russian than Hebrew."

During this period Jinkis also had a boyfriend she met in Ashkelon, a local Israeli, and on weekends she went to his family's home until a room opened up on Kibbutz Nahal Oz, less than a mile east of the Gaza Strip, and very much within Kassam rocket range.

Jinkis, however, downplays any danger on the kibbutz, saying that living there is much different from the impression one gets from the television screen. Employing the well-known defense mechanism used by people in difficult places saying there are places where it is a lot worse, Jinkis says, "Nahal Oz is not Sderot," a reference to the western Negev town that for years has been bombarded by rocket fire from Gaza.

"Rockets don't fall here all the time," she says. "It's close, they pass over, but they don't fall that much. You get used to it."

The term "Color Red" is a phrase that can send shivers down the spine of western Negev residents, and have them scuttle for shelter, because it is the warning broadcast a few seconds before a rocket is about to fall. During those few seconds, people dash for protection.

"The first time I heard 'color red' I was shocked, and cried," Jinkis remembers. "I thought, 'what am I doing here, what is happening?' At first you don't know what is going on, and then you get used to it."

Jinkis has a room in the home of her adopted family on the kibbutz, and when the alarm is sounded, she runs to the secure room in their house. "I feel at home on the kibbutz," she says, adding without noticing the irony that "except for the Kassams, the place is very pastoral and quiet."

Her parents, Jinkis says, are aware that she lives near the Gaza Strip, but don't know exactly how close or her exact location. And she doesn't volunteer the information. "Nothing has happened," she says. "What good would it do to tell them?"

After finishing Michveh Elon, Jinkis – for a reason she can't explain, other than that it was an idea that just popped into her head – wanted to be an infantry instructor. Though not accepted for that job, she was picked out of 120 girls to be an educational officer, a position that entails a two-and-a-half-month intensive crash course on educational methods and on Israeli society. She started the course, but found the Hebrew too demanding, and left in the middle.

Instead, she became a company clerk, the only female among more than 100 soldiers in a Nahal infantry unit, responsible for everything from planning cultural programs like the ceremony for Holocaust Memorial Day, to sorting mail, to just talking to the soldiers when they come back from various missions.

"I am with the soldiers all the time," she says. "That's what I like. I am a part of their unit, even though I don't carry a gun or go with them on their operations."

Jinkis laughs when asked what it's like to be the only female among 100 soldiers, and says "you get used to it." Though the language the soldiers use is often coarse, Jinkis says she is treated with respect. She spends the day on their base, the only woman in sight, and in the evening returns to a base nearby where there are other female soldiers who serve in the same capacity for other companies.

"My position is not defined," Jinkis says. "It is what you make it. What you do with it. If you want to be with the soldiers, you are with the soldiers. If you want to sleep all day, you sleep all day. It depends on how much motivation you have. I have a lot. I always want to be with the soldiers, I work closely with the educational officer and plan programs to offer them, fun things for them to do, because their daily lives are very difficult."

Jinkis says her Argentinean pedigree is actually a benefit in dealing with the soldiers. "First of all they love my accent, make fun of it all the time. Also, many of them want to travel in South America after the army, so they want to talk to me about what it's like."

Jinkis's company includes soldiers who are just a few months shy of release, and those who just recently started their service. Some open up to her and view her as someone they can

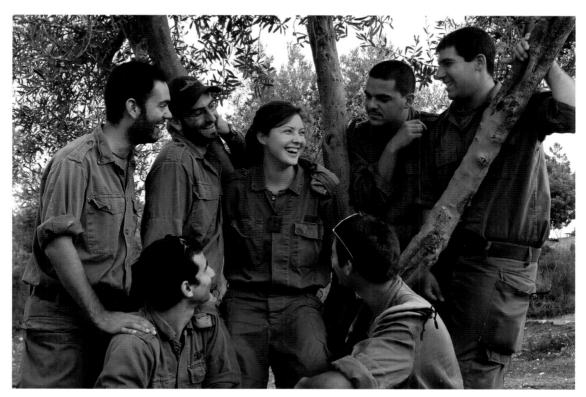

Jinkis and soldiers with whom she serves in an olive grove outside their army base.

talk to, while others are more distant. "It takes time for them to get to know you, but slowly, slowly they see that I want to be with them, help them, and they open up."

The job has given her something she wanted from the start: an unimpeded window into the Israeli mentality. And through that window she sees both the positive and the negative.

On the negative side she says many Israelis have a sense of entitlement, a sense that everything is coming to them. "Just because you are Israeli doesn't mean you deserve everything," she says. "The Israeli believes that if he doesn't get what he wants, he can scream and everything will be okay. That is a mistake, that's not the way it is."

On the positive side, Jinkis likes the Israeli penchant for saying what they think, to whoever they want – that rank and status don't matter. "It doesn't work that way in Argentina, believe me," she says. "But here it doesn't matter if you are a colonel, the prime minister or something, I can tell you what I want, how I feel."

She has also come to appreciate how Israelis view time, and that there is no rush to do things in life because of a feeling that by a certain age, certain benchmarks must be met.

"People are open, not hung up on time. Slowly, slowly," Jinkis says. "If you don't study now, you can study next year. When I say I'm twenty-one, that my friends in Argentina are almost done with college and I haven't even started, they say, 'So what, what does it matter? It doesn't matter, there is always next year. Enjoy yourself, enjoy today.' I love that."

Yaniv
Canada

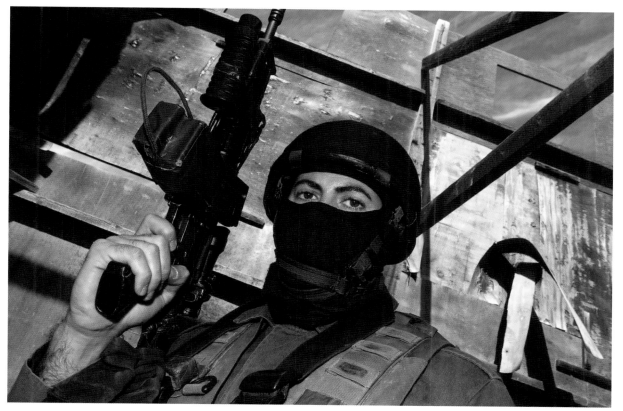

Yaniv trains in counter-terrorism combat.

The most striking characteristics about Toronto-reared Yaniv (his last name is classified because he is in a special unit) are his size, his age, and his sunglasses.

Especially his sunglasses. Actually, it is not the sunglasses themselves that are so remarkable – sunglasses are no rarity in this sun-drenched land. Rather it's that Yaniv doesn't take them off; not even on an overcast day, not even when it is customary – when talking with someone for well over an hour – to doff the shades.

But not Yaniv. He keeps the glasses on, apparently a hard-to-kick habit picked up working for more than a dozen years in the smoke-and-shadows line of anti-terrorism and secret police work.

Yaniv has learned to keep his face hidden. As such, he doesn't fit the mold; not in Israel, and not in Canada.

In Canada he was a bit of an anomaly – an Israeli-born kid who left Israel with his parents at the age of five and didn't hang out with the Jews and Israelis in school, but rather with the jocks and the body builders. A Jewish police officer – a martial arts instructor – Yaniv worked in a field where Jews are not exactly the dominant force.

And he doesn't fit the mold in Israel either. At thirty-one, he's older than almost everyone on his anti-terrorist training base near the city of Modi'in in the center of the country. The commander of the base is only two years older, and Yaniv is actually older than all his immediate officers. His fellow soldiers call him "grandpa"; he refers to them as the "grandkids."

Yaniv is a lone soldier in the army for at least a two-year stint, but unlike most lone soldiers, he had prior contact with the IDF, and even went through some basic training when he was in his mid-twenties.

His fluent Hebrew also sets Yaniv apart from the other lone soldiers, who often stick out in their units because of an inability to roll their "resh" or pronounce a guttural "ayin" like the natives.

And Yaniv stands out physically: muscle-ripped and standing well over six feet tall, with a lumbering way of walking. He trains instructors and soldiers involved in anti-terrorist combat in the martial arts, particularly the unique Israeli mix called Krav Maga, an eclectic, Israeli-developed self-defense and hand-to-hand combat system.

But it's all a bit mystifying what Yaniv does exactly, and this adds to the mystique, fitting in well with his sunglasses persona.

What is clear is that Yaniv, who holds a black belt in both tae kwan do and Krav Maga, and who was a North American champion in tae kwan do and Thai boxing, gives martial arts training.

Not only does he train soldiers in special anti-terrorist courses at the base, he also trains the trainers. And one thing the trainers do is deliver body blows to fresh recruits.

The Krav Maga trainers at bases across the country regularly take soldiers out of their bunks in the middle of the night, stand them up with their hands above their heads, and deliver well-directed blows to the midsection until the trainees fall to the ground. It gets them used to taking a beating, and is part of the training all soldiers in the IDF's elite units undergo.

Asked his advice to those on the wrong side of the exercise – those getting punched, not delivering the punches – Yaniv replies: "Close your eyes, think of something happy and remember that eventually everything ends. That's what keeps things going. Unfortunately good things have an end, but bad things end as well. They take longer to end, but they also end."

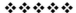

It's a philosophy that Yaniv applied to his own life as a young child in Canada. He was born in Beersheba, the son of a Moroccan-born father and Russian-born mother who met on a

Negev kibbutz. At five he moved with his parents to France, where his father – a career military man and security official – worked in some state-related job that Yaniv can't talk about; to this day he doesn't even know what exactly it entailed.

The transition from the Negev to France, Yaniv says, wasn't easy at first. In Israel he lived on a moshav called Talmei Eliahu, with open space and a lot of pets. He remembers it as being in the middle of nowhere, "boring, but fun.

"We had a lot of neighbors over there, and I had a lot of friends," he says. "There were a lot of dogs on the moshav, and they were my friends – I love animals. I had a collection of toy cars, and every week my mom would buy me a new car from the local store. When we were leaving I buried them in the front yard, to keep them in a place where I wouldn't lose them until I could come back. I was sure we would come back so I could get my cars."

But the family didn't come back, and instead moved from France to Toronto, where some of the family's relatives had settled.

"It took me a long time in Canada to come out of my shell, to make friends and be a normal kid," he says.

"I remember in the sixth grade there was a group of kids two years older who were bullies and always picked on certain kids. I had a very good friend at the time who was half Jewish, half native Indian. He had long hair, and they always picked on him because of that. One day it came out that we were both Jewish, and every day they would bully us because we were Jewish. One day they came to school with swastikas on their pants – it got serious."

That experience, and other similar ones in high school – such as when friends who didn't know he was Jewish made derogatory statements about Jews – did two things: helped him form his Jewish identity, and pushed him to excel in the martial arts.

At first, Yaniv just tried to ignore the anti-Jewish comments and blend in with his friends.

"I wouldn't identify myself as being Israeli. I would always say that my dad was French and my mom Russian, and I was only part Israeli. That was okay, see, because I was only part Israeli. Since I wasn't fully Israeli they accepted me. I just went along with this. I wouldn't stand up for myself or my heritage, and wouldn't do anything that would negate my being in this circle of friends."

As he got older, however, when he saw some of his cousins return to Israel to start the army, "I started thinking about what was important for me."

In addition to forming his identity, these incidents also shaped another facet of his personality: the Clark Kent facet.

"When I would get bullied as a kid over there, I always told myself that one day I would be really big and really strong and would hunt down every single person that bullied me around or beat me up, and give them a taste of their own medicine," he says with a laugh, bullet fire from a shooting range on the base punctuating his comments. "That was my goal since I was a little kid – to be big and strong and good in martial arts, and to be real life RoboCop and Terminator and do justice in the world."

Whatever the motivation, whether the influence was the movies or the bullies, Yaniv stood out from most of his peers by showing an interest in military, police, and security work.

"This was natural for me," he says, "It ran in the family. Already by my later years in high school I knew I was going to go into the military and policing fields. I trained in Krav Maga since I was four years old."

When Yaniv was eighteen, his tae kwan do instructor organized a security detail for a South Korean politician visiting Canada. He asked Yaniv to get involved in this secret service-style work, and Yaniv has remained involved ever since, traveling – in this capacity – all over the world.

He did this for a number of years, specializing in Krav Maga and eventually working as a "civilian instructor at a police college for defensive tactics." He also traveled back and forth to Israel, and spent a few years in the country intermittently during his twenties.

"I wasn't sure at the time if I wanted to come back here to live permanently," he says. "When I was here I felt a very long way away from my friends and family."

Nevertheless, he kept coming back – both to work and for Krav Maga training – and each time he stayed a bit longer and got more used to it. "In my late twenties I really began missing Israel when I was away."

His parents, however, were not crazy about the idea.

"Before I came back to Israel the very first time in my twenties, I talked to my dad about it," Yaniv says. "I was sure he would be supportive, having been in the service himself here for so many years. His response was 'over my dead body, you're not going back.'"

His father's opposition, Yaniv says, was not out of any enmity to Israel, a place with which he had kept close ties. "I guess he was just being a father. This was 1996, and there was a lot of conflict going on in Israel."

Yaniv had relatives in the army, who would tell their parents stories, which they then retold to his own folks. "They just got kind of over-protective about it all," he says.

At first Yaniv overcame their opposition to his trips to Israel by saying he was just going for short trips for Krav Maga training with an organization he was part of. But during one trip, when he decided to do some army training, he called his parents and said this time it would be a while before he returned.

"When I came home my folks said, 'Good, you got it out of your system, now it's time to stay here and focus on what you need to do here, focus on your career.'"

But he wasn't able to. Yaniv was pulled back to Israel on both a professional and an emotional level.

On a professional level, Israel – for those involved in security work – is definitely the place to be. It's like Silicon Valley for computer engineers, Hollywood for screenwriters, New York for bond traders.

"Security is the field I love," Yaniv says. "From a professional perspective a lot of what I do work-wise is also my hobby – everything that relates to police, military, security, and

counterterrorism. Israel is a country that has always faced terrorism and as a result deals with it at a very serious level – more than elsewhere.

"It's like if someone lives near the water, they will always know and respect the importance of swimming," he says. "But if you live inland, and only see the water once in a while, you might say, 'It might be important to swim, to learn a few strokes here and there, but I won't really embrace it because I won't really need it.' That's the mentality outside of Israel when it comes to counterterror."

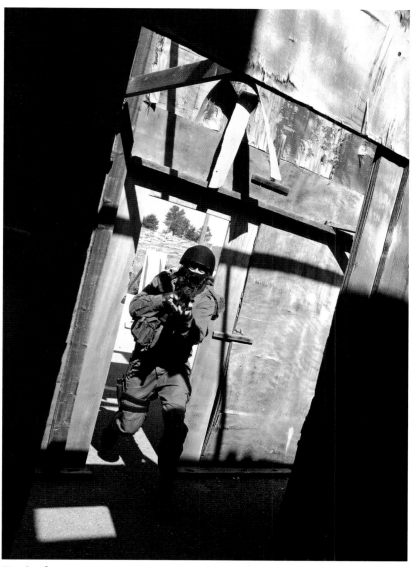

Yaniv demonstrates counter-terrorism techniques at a training base equipped with a model Arab village.

Professionally, Yaniv wanted to live near the water, even in the water. "This is where things are really happening in my field, and I want to be where things are really happening. I reached a point where I felt that if I were to carry on in this field, I wanted to do so where I could do so optimally and without any games, and do my work the way things needed to be done."

And then there was the emotional side as well. "This has always been home," he says. "I always felt that way, even though it took a while when I was growing up in Canada to identify with that. But that's what I felt whenever I came back here, and coming back here kept reinforcing that feeling."

At a certain point, he also concluded that if he was going to give of himself, and risk himself, it might as well be for something that has "a lot more meaning, a lot more importance."

"Our place is here in Israel," he says, "not just because this is where the Jewish people are, but because we have to make sure we have a place in this world where we are always welcome. That also weighed in on my decision to come and invest my time and energy in keeping this place safe and keeping it in existence, and being where I belong – with other Israelis."

Yaniv says that at a certain point he felt that all his days in Canada were the same, the same routine, and "it just got to the point where I said it's time to break the routine, and I just came back."

That time came in the summer of 2006, during the Second Lebanon War. "I had relatives and friends in the field fighting, and I just said to myself it was time to get things done as quickly as possible and come back and join up. I said it's time to go back now."

It wasn't that easy, however, because Yaniv didn't fit neatly into any category. He wasn't a lone soldier in the classic sense of the word, since he had some previous IDF experience. Yet, at the same time, he was a lone soldier in that he was coming back to the country alone, and was volunteering to serve.

"It took a couple of weeks to get all my paperwork squared away again," Yaniv says. "They had to first see where they were going to place me. I was a bit of a strange case for them, coming back just before age thirty, with some service under my belt." His résumé floated around a number of different IDF units, before, he says, he was "scooped up" by his current base.

Once there, it took some adjusting. Because of his age and his experience, it was "awkward at first for everybody," Yaniv says. He had to go through part of a specialized course to certify martial arts training instructors, and found it difficult at times dealing with his twenty-year-old instructors.

"A lot of times I pointed things out to them while they were teaching," he says. "They didn't know what to make of me, and didn't understand the whole situation."

Yaniv says at times he feels very much like an outsider, "a part of the puzzle, but not the piece that fits into the middle."

"Okay, I'm here and everybody on the base is talking about going drinking on the weekend, and wants to play video games," Yaniv explains. "And I'm thinking that all I want to do is go home and sleep and call my family. From the aspect of where I am in life – I'm thirty-one years

old with different priorities and different perspectives – I feel sometimes like I'm a bit of an outsider. But because I'm Jewish, Israeli, a soldier, and this is my country – I feel the same as everyone else."

He says things were definitely easier in Canada. "I woke up in the morning and had nothing to worry about. No problem paying rent, no problem buying a car, no problem going to get something to eat. And whatever I wanted to do that day, I could get up and do it. Here," he says with great understatement, "that dynamic is different."

Yaniv readily admits to missing a lot about his life in Canada. "But there is a flip side as well," he says. "There are elements here that just give me peace of mind, a feeling that I'm in the right place.

"I might be on the bus somewhere, or in a shopping mall, and hear someone speaking Hebrew, or French, or a language from somewhere else, and I'll turn around and see them wearing an army uniform. Or I'll talk to some people, and it'll turn out that they grew up somewhere else.

"That is what makes this country stand strong. As Jews we are all over the world, but a lot of all these people are coming here to make Israel what it is, to make it happen. It is not something you can get anywhere else. You can walk around Canada and hear every language imaginable, but everybody is there because, you know, they want a better life, or better opportunity. There is no commonality. But here it doesn't matter where the people are from, or who they are, there is that commonality."

Which doesn't mean it is easy. Yaniv says his absorption process was made more difficult because he came to Israel and went directly into the service. Although this was out of his own choosing, it did not give him the "buffer" that others have.

"I didn't have a lot of time to settle in and get things organized," he says. "Everything fell on my shoulders at once and caused a little bit of stress in the beginning."

He ended up going to live on a kibbutz – pulled there, maybe even subconsciously, by a desire to follow in his father's footsteps. His father also came to Israel "with all sorts of ideals, started as a kibbutznik, went to the army, and moved up that way.

"I always heard stories growing up what it was like on kibbutz, and thought it could be a good thing to explore," he says. The kibbutz he decided on is Zikim, in the south.

"I decided on Zikim because it is one of the very few traditional kibbutzim left," he says. "The people are really very wonderful, and it is absolutely beautiful. It's a quarter of a mile from the sea. I open up the front door and have a view of the sea and palm trees everyday. It makes a world of difference – and the most important thing is that it is far away from my base."

It is also just a mile and a half from the Gaza Strip, and therefore well within Kassam rocket range. Or, as Yaniv put it, "Kassams always fly right by us, and sometimes hit us."

Paradoxically, the kibbutz's location in the middle of the action is another draw for Yaniv. "The kibbutz faces a number of threats," he says, "both day and night. Whether it is a Kassam rocket falling or a terrorist trying to sneak in from Gaza. So that's where I want to be – to try and keep things safe."

In a nutshell, that is also why he returned to Israel.

Ariel Lindenfeld
United States

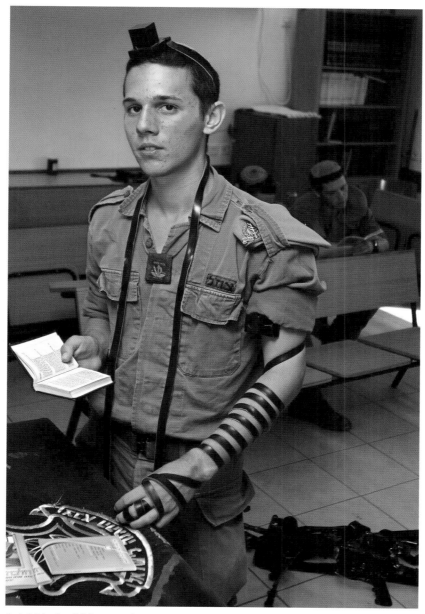

Ariel Lindenfeld prays in morning services at the synagogue on his Nahal base.

There are certain locales in the New York area, places like Teaneck, New Jersey, and the Five Towns in Long Island, where self-contained Jewish communities have emerged that provide everything a modern Orthodox Jew requires: fine schools and yeshivot, a plethora of kosher restaurants, numerous synagogues, mikvaot, bakeries, adult learning opportunities, youth groups, and book stores.

On Shabbat and holidays, it is the norm to hear the prayer for the State of Israel, and the prayer for the welfare of IDF soldiers, recited with feeling in synagogues in these communities. And this is just one thing that sets these communities, which are ardently Zionistic, apart from nearby non-Zionist hassidic neighborhoods.

For many families living in these upscale and pricey towns, Israel is literally the center of their lives. They vacation in Israel in the summer, send their kids to study in yeshivot in the Jerusalem area for a year after high school, worry constantly about the security and political situation there, give money generously to Israeli institutions, log on regularly to *The Jerusalem Post*'s website, and are active in a variety of pro-Israel organizations.

In places like West Hempstead and Lawrence and Cedarhurst, dozens of Jews can be seen strolling to synagogue on Shabbat, walking around with their kippot and *talitot* as if it were the most natural thing in the world. Jewish life in these communities is rich, full, and extremely comfortable.

So rich, full, and comfortable that – despite the dedication and devotion to Zion of so many of those who live there – there is no real need to move to Israel to live fulfilling Jewish lives: They have everything Jewishly they need right there. Indeed, these communities have been described as "Israel without the problems," or "Zion without the hardships."

And it is in just such a community that Ariel Lindenfeld, a slightly built, angular-faced, bespectacled nineteen-year-old in the midst of IDF basic training, was born and raised.

"One of the questions I'm always getting asked about being in the army is whether my parents are OK with it," says Lindenfeld, sipping a hot chocolate at a coffee shop on a hot day in the humid town of Beit Shemesh. "I'm like, it's their fault. I mean that as a joke, but it's true. Kids don't just randomly come up with this idea of joining another country's army and leaving their family. It's got to come from somewhere."

And in Lindenfeld's case, it came from his environment in Woodmere, Long Island – a Zionistic family, a Zionistic community, a Zionistic synagogue, and a Zionistic school that he was sent to.

What surprises him, however, is that it is not innately understood that a product of this type of environment would in the end want to "walk the walk" and join the IDF.

And what surprises him even more are the parents of friends who raised their children in a similar milieu, who planted in their children a love for Israel, but who actively oppose their kids moving to Israel or joining the IDF.

"I have a friend who was with me in high school and always said he was going to go into the IDF. All the time. He went to a Zionist school, and his parents were also Zionistic. But

when it came down to it, his parents didn't want him to be so far away from them, and they definitely didn't want him in the army."

After spending a year in college in the US, Lindenfeld's friend is taking a couple of years off to come to Israel and – against his mother's wishes – join the IDF. "His dad is okay with it, but his mom isn't. She is afraid for him. But he is still coming. I hope his mom will come around, and in the end not stay angry forever. I'm sure she will still want a connection with him."

Lindenfeld didn't have the same trauma. His parents, Zionists who contemplated aliya seriously a couple of times when their three sons were small, didn't object to his decision to join the army within the framework of Machal Hesder, the program that combines yeshiva studies with shortened army service for youth from abroad. Instead, they just wanted to make sure his decision to serve in the IDF was his own, and that he was making it for the right reasons, not because he felt pressured into it at Yeshivat Hakotel, a Zionist yeshiva in the shadow of the Western Wall where he studied for a year after completing high school, and where all the Israelis go into the army.

"I don't know if I would have been able to do this if my parents were opposed," says Lindenfeld. "Their support is extremely important and necessary for me. It is one thing to do something extremely hard; it is another thing to have to convince other people to let you do something extremely hard."

And the idea of having a son in the army, he says, is not an easy thing for his parents. Indeed, he believes the prospect of having kids in the army is one of the factors that kept his parents from immigrating many years ago.

"When I was a kid we'd come to Israel about every summer. We'd rent an apartment and my two brothers and I would go to day camp," Lindenfeld says. His strongest memories from that time were not the Kotel, or Masada, or coming to an appreciation of the significance of a Jewish state, but rather eating kosher Burger King – one thing they don't have in Woodmere – as well as seeing brand names, such as Coke, written in Hebrew.

Lindenfeld's parents themselves spent time in Israel when they were his age, studying in Jerusalem-area yeshivot. "They were very Zionistic, though I don't know where they got it from. I guess from their parents. All my grandparents went through the Holocaust. On my father's side they went into the concentration camps and stuff like that, and on my mother's side it was hiding in different places."

Lindenfeld said his parents considered aliya seriously on two occasions. "I remember once, I was in seventh grade, and they didn't really want to tell us they were planning on making aliya, because they weren't sure it was going to work out. But we went to the doctor, got pictures taken, visas, the whole works. In the end, for various reasons, it didn't work. The problem is that now every time they come back to Israel they revisit the idea, the possibility."

There were many considerations, questions about timing, that kept his parents in the States. "I think that what was always in the back of their minds was that they have three sons,

and if they made aliya they were going to have to send their three sons to the army. I think they once told me something like that. That had to affect them some way. I'm sure anyone with three boys would have weighing on their minds the thought that they would be going into the army some day, which no mother or father really wants."

Isn't it ironic, Lindenfeld is asked, that one of those three sons – the oldest – ended up in the army anyhow?

Not so much, he replies. "There is a difference between them saying, 'Oh, I am going to move to Israel and then my sons are going to have to go into the army,' and one of those sons deciding on his own that that is what he wants to do."

But it wasn't a given. Lindenfeld wasn't a natural candidate either for aliya, or for the army. In fact, when he was in seventh grade, and his parents were considering the move, he – and not his two younger brothers – was the son who objected.

"I was the one old enough to realize that the change would be very hard," he says. "It was the basic kid things: going to a new school, making new friends. When I think about it now it seems kind of weird, that I was the one opposed, and that now I'm the one – out of the three – who most wants to live here."

The army, too, was never something he felt compelled to do when he was growing up. "Until the tenth grade I was always short, really short," he says. "I always had it in my head that I was too short and weak for the army, that it was something for the strong. I used to think, 'I'm not even good at basketball, so how could I possibly do the army?' When I was in high school I thought, 'Wow, that's amazing that people are going into the IDF, but it's not for me.'"

Indeed, Lindenfeld doesn't look the military part. Slightly built, somewhat wiry, with a computer under his arm, he gives the physical impression of a "computer techie," a description he admits is not wholly inaccurate. Although the IDF has a great need for computer whiz kids, Lindenfeld says he dismissed the idea from the start.

"It was like, if I was going to do this already, I wanted to go all the way and be in a combat unit."

Like so many kids in his class at the Rambam Mesivta High School in Lawrence, when twelfth grade rolled around Lindenfeld started applying not only for colleges – like so many others his age around the country – but also for yeshiva programs for his post-high school year in Israel. He arrived in the country for the experience two weeks before the Second Lebanon War in July 2006, but says he wasn't spooked by the war, because he had been in Israel before during trying times, specifically during the Palestinian terrorism of the early 2000s.

In the yeshiva he met other "short and weak guys" – both Israelis and Americans – who were in the service, and his perception of what was needed to make it in the military changed. Though his original plan was to study for a year in the yeshiva and then go back to the US to

start college, once in Israel he opted to join the Machal Hesder program, a program that combines at least six and a half months in the yeshiva with fourteen and a half months in the IDF.

"I spoke to a lot of people there about the army, and started to realize that if it is something that I feel is important, and something I want to do, then I could do it. But even two months before I went in, I was still asking myself whether it was really something for me. I always thought about it, that it would be interesting. But I didn't think that physically or mentally I would be able to manage."

What changed?

"Either coincidentally or on purpose I started talking to people – both Israelis and Americans –and said to myself, 'Hey, look at him, he is also a little guy,' or 'Look at him, he also came from my neighborhood.' I started to realize that if people so similar to me could do it, so could I."

But then he had to address another question. Why? Why go through it all?

While he says he believes that IDF service is a religious obligation, this by itself – in light of the fact that so many other Orthodox and ultra-Orthodox youth don't do the army – probably wouldn't have been enough to compel him to take the step.

"All I think about is my grandparents and the Holocaust," he says, speaking while in his third month of seven months' basic and advanced training in the Nahal infantry unit. "The Holocaust is one of the biggest things for me, thinking about what would have been had the army, the state, been around then. How impossible it would have been for that all to happen. And now that we can defend ourselves, I want to be a part of doing that."

Lindenfeld says that keeping that "big picture" in mind is a key to making it through basic training, being able to crawl up hills through fields of thorns and down again over piles of rocks. "If you have a good reason for doing it, then you can get through the hardships, then you can work past all kinds of stuff," he says.

His "big picture" is also made up of a sense of civic – not only religious – duty: a feeling that if others are serving to protect a country he hopes to live in, then he should do so as well.

Secondly, he is looking a couple of moves down the road, at a time when he will be married with kids, and thinking how difficult it would be for him to urge his children into the army, had he not served himself.

That is all on the mental, theoretical plane. On a practical level his service has been made a bit easier by having a comfortable living arrangement outside the army, and by going into a unit with guys he was already friendly with.

Unlike most other lone soldiers, who usually either rent apartments or live on kibbutzim,

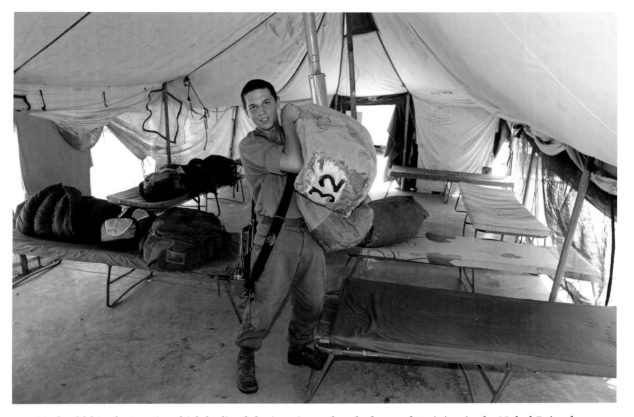

Lindenfeld in the tent in which he lived during six weeks of advanced training in the Nahal Brigade.

Lindenfeld decided to live in Beit Shemesh with close family friends who made aliya a decade ago and have an empty guest room they set aside for him.

"When I first started at the yeshiva I never went there for Shabbat," Lindenfeld says, referring to how students from abroad often go to people's homes around the country for Shabbatot. "But then once, I went there and realized how comfortable I was. The truth is that even before I was a hundred percent sure I wanted to go into the army, they were already saying, 'You'd better live with us.' I still ask my parents why they are helping me so much.

"On the one hand I know they were really close family friends, but on the other hand I just don't get it. Why do they want to take someone in so totally? What they do is amazing. I don't know how to put it any other way."

Lindenfeld has his own key and his own room, and free access to the refrigerator. "I'm comfortable there most of the time," he says. "It is relaxing, as close to home as I can get." There are three other homes in the immediate neighborhood where families have taken in lone soldiers in similar circumstances.

Some of Lindenfeld's friends from the yeshiva rent apartments together, and seem to like

it. But, he says, they still go to different families every time they are out of the army for Shabbat. "I would end up coming here every Shabbat anyway, so what's the point?"

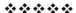

While being comfortable in living arrangements outside the army is important, being comfortable inside the base is critical. And a key factor to that comfort level is being with other soldiers one feels at ease with.

Although the vast majority of the army's units are a mix of secular and religious youth, a few units are made up exclusively of yeshiva students who do what is called *hesder*, a service made up of eighteen months' active army duty, and thirty-six months of yeshiva studies. Lindenfeld is in such a unit.

There are some thirty soldiers known by the acronym *beneishim*, or bnei yeshivot (yeshiva students), in his unit, of whom ten are lone soldiers doing the somewhat truncated version of hesder, Machal Hesder.

"It is a good support system," Lindenfeld says. "One of the hard things about going into

Lindenfeld joins other lone soldiers in a joint military/yeshiva program studying Talmud at his Nahal base synagogue.

the army is that it's like going into school all over again. You don't know anyone, and have to make all new friends. But I'm with guys who I knew beforehand, and it just gets rid of a whole aspect of adjusting."

Adjusting to the army is a chore not only for lone soldiers, but also for native-born Israelis, who must get used to both the physical challenges of army life – little sleep, lots of running, push-ups, martial arts training, and long, long hikes – and also the mental challenges that come with the sudden loss of freedom.

"It helps to have a good friend there to back you up, get you through the hard times," Lindenfeld says. "The regular soldiers make those friends after a few months in their units. But it was helpful already having those friends with me.

"Everything in the army is about other people helping you," he says, explaining the importance of this support. "One of the things the army tries to get through to you is that you can't do anything by yourself; that you have to rely on each other. That means that if one person is missing a piece of equipment, everyone is; or if one person has to wait, everyone has to. So if you already have people who you can rely on, and who can rely on you, it makes things easier."

Unlike many of the soldiers, most of the lone soldiers in the hesder program do not go through the pre-army preparatory course for new immigrants at Michveh Elon, because they do not need the Hebrew language ulpan, having mastered at least a rudimentary knowledge of Hebrew in the yeshivot.

Michveh Elon, however, serves another purpose, letting the soldiers – who have little idea of what to expect – get their toes wet before being thrown fully into the pool. Lindenfeld, however, says he got a pretty good idea of what to expect from talking to the Israelis in his yeshiva beforehand.

"I was there a year and a half before going in," he says. "There were soldiers walking around all the time who you talk to, who tell you stuff. I had an idea, I didn't go in completely cold.

"I always looked at the army as a no-fly zone," he says. "Like there was no way I could ever do it. Now one thing I have in the back of my head is that if I can get through this successfully, I can get through so many other things. Whatever I'm doing later in life, I can look back and say, 'I got through the army, I can get through this as well.'"

Anat Lev

Dominican Republic

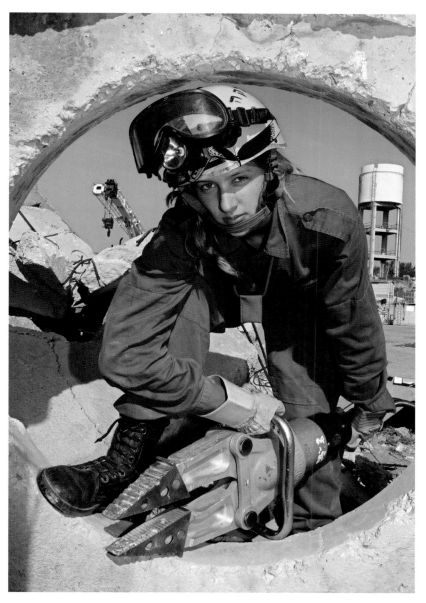

Anat Lev uses high-powered tools for cutting through metal bars and concrete at the training base of the Home Front Command's rescue unit.

Standing at an army roadblock outside Kalkilya, checking Palestinian cars going in and out of that large West Bank city, twenty-year-old Anat Lev – wearing a helmet and ceramic bullet-proof vest, and carrying an M-16 – is both physically and emotionally thousands of miles from where she was raised.

Born and raised in Santo Domingo in the Dominican Republic, Lev is the daughter of an Israeli who – like so many other Israeli youth who finish their army service – traveled the world. Unlike most, however, he journeyed to El Salvador, met a girl, married, moved to the Dominican Republic, went into business, and stayed put. That is how in a society dominated by names like Alvarez, Sanchez, and Rodriguez, there was also an Anat Lev.

But the distinctly Israeli- and Jewish-sounding name shouldn't fool anyone; Lev, one of only three Jews in her high school, grew up knowing very little about Israel, Judaism, or Jewish history. So little, in fact, that as an adolescent she got into trouble in school for aimlessly doodling in her notebook and coming out with a figure that eerily resembled a swastika. The teacher was aghast, relieved only when she concluded that Lev genuinely had no idea – as she protested – what that particular symbol represented.

"I was very naive," Lev says. "I didn't realize wars existed until I was about twelve years old. It sounded so barbaric. It is a very closed world over there. No one really understands what is happening."

With only about 100 Jews in a country of some nine million people, the Jewish educational opportunities in the Dominican Republic were rather limited. Indeed, all Lev's mother – a convert to Judaism – hoped to find for Anat and her two brothers was a school that didn't teach Catholicism as part of the curriculum. As a result, she went to an American school in the capital, which explains why the Dominican-born Lev, the daughter of an Israeli father and an El Salvadoran mother, speaks flawless, American-accented English.

Despite the almost complete absence of a Jewish community, Lev remembers her family always marking Shabbat at home, with her mother lighting Shabbat candles and her father saying Kiddush.

"I kept kosher until sixteen, but in a Reform way. There was no kosher meat, but because my father worked in Miami, he would bring us kosher meat home from there. When he stopped working at that particular job, my mom asked me if I was going to go through life not eating meat. I saw that as her approval to eat non-kosher meat."

Having grown up in a country where Judaism was completely foreign, Lev is delighted by Israel's innate Jewishness. "It's nice to go outside on Yom Kippur, see no cars and realize that almost everybody is fasting. It is nice not to feel that you are the only one doing it."

Which is exactly how she felt back home. "We would walk on Yom Kippur to the synagogue, but it was very weird. It was uncommon, because nicely dressed white people don't usually walk in the streets there. Everyone has cars, and they drive wherever they go. It's hot, and also dangerous. I felt weird and embarrassed. Here it is amazing to see everyone doing it."

Yet, unlike some lone soldiers who come to Israel out of a fiery Jewish or Zionist commitment, or some children of émigré Israelis who return to do the army out of a sense of deep obligation implanted in them by their parents, Lev's journey was motivated more by purely practical considerations.

"When I finished high school I wanted to study fashion design in my country, but you had to be eighteen to enroll, and I was only seventeen," she says, sitting in an apartment she shares with a roommate on Kibbutz Ein Hashofet. "I had nothing to do for a year. I wanted to go to the US to study, but it cost too much. I didn't want to stay at home and do nothing. So my dad started talking about Israel."

Although her father is Israeli, Anat knew surprisingly little about the country. She visited once when she was an infant for about a week. She had no memory at all of her grandparents, nor had she ever met her aunt and uncle, who live in Caesarea and Tel Aviv respectively. Her father did talk about Israel and his time in the army, but the rest of the family had difficulty relating to it: The reality he described was completely detached from anything they could imagine in their part of the Caribbean.

"I thought of Israel as a desert, where everyone looked Arabic," says the sandy-blonde, blue-eyed Lev. "I wasn't sure what I would do there, but my father said it was a developed country with good study opportunities."

Growing up without any connection at all to the Israeli side of her family, Lev says the prospect of meeting her aunt, uncle, and four cousins – all of them girls – factored into her decision to heed her father's advice. Finally meeting some extended family was an emotional experience for her, but much less so for her cousins. "They had cousins, so another one was no big deal," she says. "But for me it was it was something brand new."

Lev arrived in 2004, during the height of the second Palestinian intifada that substantially altered Israel's mood and feel. Her mother, who had lived in Israel for a couple of years when first married, was not overly concerned about the country's security situation, and was happy with her daughter's decision.

"She felt the same thing that my dad did: that this was an opportunity to go places. My country is an island, and it is not that easy to leave and go elsewhere."

Either by coincidence or, as Lev jokes, by a stroke of fate, the Jewish Agency emissary from Mexico just happened to be visiting the Dominican Republic when Lev began talking about the possibility of coming to Israel. He took care of all the paperwork, and arranged for her to study Hebrew at an ulpan on Kibbutz Ein Hashofet in the green hills of Ramat Menashe, some twenty miles southeast of Haifa.

Lev tells her tale after she has completed some eighteen months of her twenty-four-month stint of service, and during a week off from the army, a week spent organizing a new two-room apartment she has just moved into on the kibbutz. A couple of colorful paintings she drew take pride of place in the small living room. The small unit, in addition to the living room, has a kitchenette with burner and microwave oven, a bedroom, and bathroom. There is a television, tuned in to a soap opera, and a computer.

Although Lev signed immigration papers when she came to Israel, she says she did not fully internalize the significance of aliya when she first arrived.

"When my uncle took me to the ulpan I was in shock; I didn't know what I was doing. I signed the aliya papers, but I didn't know exactly what it meant. People said I would get financial help, and aid studying; that I would get this and that. But I didn't come here for that. I didn't come saying to myself, 'I want to come to Israel because of the help they are going to give me.'"

Beyond financial assistance and tuition grants, however, Lev received something else shortly after arriving: a draft notice. Her induction orders arrived some ten months after she set foot in the country.

"Everyone always talked about the army in the ulpan, but I really had no idea what it entailed," she says.

Indeed, in her native land the army was not something her circle of friends aspired to. "Back home it's not something that everyone does, only a place where the poor people go. It is not thought of as something prestigious," she says. "I thought every army was like that, that only the poor or the rebels go in. But after I was here for a while it became clear to me that this was not the case. I started to look at it differently. I also thought it was important to go in to understand the Israeli mentality."

Although Lev was told before she arrived that army service was optional, once she arrived – and received her draft notice – she was told it was mandatory. She never did find out which version was correct.

Nevertheless, in January 2006, less than two years after arriving, Lev headed for Michveh Elon. Her main worry at the time was the thought of having to spend two years in the IDF, not an insubstantial amount of time for someone who had lived for only eighteen.

She wasn't concerned about the discipline or the physical difficulty, saying that as a former member of the Dominican Republic's national synchronized swimming team she was used to both regimen and authority.

"The thing I was worried about most was being eighteen and not starting my studies," she says. "In my

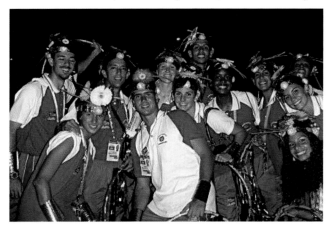

Lev (lower left) as part of the Dominican Republic delegation to the Pan American Games.

country everyone in my class had started studying. But I was excited," she laughs. "I thought it would be a *G.I. Jane* type of thing."

Lev isn't kidding. She had no desire to spend her time in uniform fetching coffee for officers, or pushing papers, or teaching English to other immigrants. She wanted a combat role. And her image of what awaited her was largely shaped by the 1997 action film *G.I. Jane*, featuring Demi Moore as the fictionalized first woman to undergo Special Operations training in the US army.

Lev quickly realized that Israeli army life does not imitate Hollywood, and that she was not going to be the Israeli incarnation of G.I. Jane. Her aspirations were set too high – on positions beyond the reach of most women in the IDF. It didn't take long before she understood that she would not be dangling from a helicopter in a search mission as part of an elite aeromedical unit, nor would she be jumping out of airplanes as a red-booted paratrooper.

Lev spent three months at Michveh Elon, and was mightily impressed by the motivation of the other immigrant soldiers, who all seemed to want to be there. Unfortunately, she says, that pitch level of motivation is not always apparent in the "regular" army, where she often comes up against people who would like to be anywhere else but in the army.

"That is emotionally very difficult, especially when you go into a combat unit and find people asking what they are doing there," she says. "It brings you down."

But at Michveh Elon, Lev was still very much on an initial "high." It was there that she learned a lesson that would serve her well later in her service: don't take "no" for a definite answer. When she was told that there were no combat positions open for her, she pressed further and found that there were.

Lev was interested in being part of a search-and-rescue team, and pushed her way into such a unit connected to the IDF's Home Front. While this unit's specialty is extracting people from rubble, on a day-to-day basis the team – which consists of both men and women – performs routine operations in the West Bank.

"During training we looked like construction workers," she says, describing a training site strewn with huge concrete slabs to simulate fallen buildings, and soldiers wearing goggles and wielding heavy drills. "But that was only in training. Rescue operations happen once in a very great while, in fact, they actually almost never happen."

Following the rescue training, Lev's unit spent a few months guarding a prison, work she describes as drudgery. This was followed by reassignment to the West Bank, where the unit's duties changed and became more combat-oriented.

"Now we are doing things that are more combat-like, seeing the real side of what it means to be in a combat unit. It is not G.I. Jane, it is not being in the field all the time, but still..."

Combat duty, as Lev has come to appreciate, is not twenty-four hours of nonstop action.

Combat duty is manning roadblocks for hours, guarding bases. It is often tedious, a tedium that is inadequately portrayed in movies that often give a distorted image of army life, an image, however, that many of the country's youth have in mind when they go in.

"At roadblocks we sit for hours at a time, looking at the same thing, watching for something that might happen once a month, or once or year, or maybe never," she says. "Sometimes when I complain about it, people will say, 'What did you think you would be doing?' I really didn't know anything. I saw movies, and that's what I thought it would be like. I thought there would be more action, more fighting terrorists.

"I'm in the same place for four months and nothing has happened," she says, almost regretfully. "It doesn't mean that nothing is going to happen, but still, nothing has happened."

Like so many of her male counterparts in the army, Lev is itching for the proverbial "action."

"Sometimes we go into Kalkilya. But mostly the boys go in. Occasionally they let girls go in. Once I went in and we surrounded a house and made sure no one came out. We had to find a man who was supposed to have a weapon on him. We found him, but not the weapon."

Lev says she liked that particular operation. "I wish there was more of that. I felt like I was in danger, that I was using what I learned in training. I like action."

Still, she says that even though life in the army is not continuous excitement, she doesn't regret her decision to go in. "Like everybody else says in the army, it is good to do it, but once it's over, it is good that it is in the past. I think it is something you appreciate when you are finished; you feel a sense of achievement. For the boys who go into combat units, it is also an opportunity to test their limits, to let them see what they can really do with their bodies."

The entire experience has changed her life outlook. "Being with so many people with such different mentalities, and people who have gone through so many different things, gives you a different perspective on everything. It helps you understand them, be more open to them."

The army, she says, has taught her to accept people from widely different backgrounds and cultures, and to learn both to accept them and get along with them.

"It taught me that things will not always be how I want them, or what I expect, but that I have to accept that and deal with it. It has made me more independent and willing to stand up for myself. It has also given me a greater understanding of Israeli culture, helped me understand where the Israelis are coming from."

Another important thing the army gave her, she says, is a course in basic Judaism called Nativ, which is offered to non-Jewish Russian and other immigrants with a minimal knowledge of Judaism. She speaks glowingly about the course, and recommends it be made available to all soldiers, not just immigrants. "Israelis themselves should do this course to understand who they are, what they are doing in the army. It's very important.

"In that course I got to understand assimilation, and that if Jews get together with everyone else then everything will start to disappear. It is sad, and I see it with my brothers. One of them is coming here, and will probably come on aliya." Another brother moved to Argentina, and Lev says he does not understand the importance of marrying a Jewish woman.

"But I also didn't really understand the importance of marrying someone Jewish until I came here," she says

Why not?

"Because in my country I thought, 'what does it matter? I can still be Jewish and marry someone who isn't.'" Israel, she says, gave her a different view on the matter. Indeed, Israel has given her a different view on many issues. But as to whether she likes the country enough to want to stay and establish her life here, she remains equivocal. "I still haven't found my place here," she says. "But I don't not like it."

"There is scenery in my country that you don't have here, and I miss that," Lev says. "It takes time to get accustomed to everything, including the vistas, and the people. I need to finish the army now and get to know the Israelis better. In order to love a place you have to build memories around it. That's what I'm starting to do."

Ben Froumine
Australia

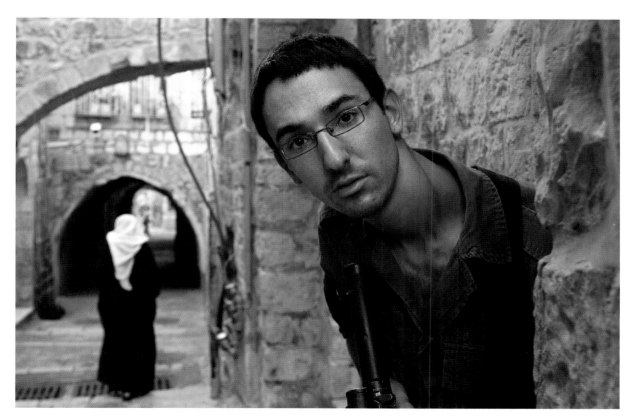

Ben Froumine on patrol.

Night after night, week after week, month after month during the height of the Second Intifada from September 2000 to the end of 2005, the international news organizations broadcast reports and images of the raging conflict in Israel in ways that made many of those concerned for the country's well-being shudder.

Now there were jarring efforts at exhibiting "holy balance": interviewing the parents of victims of suicide bombers, as well as the parents of the bombers themselves. Then there were harsh images of Israeli military action, sans context: tanks rolling over cars in Ramallah, without any explanation why those tanks were there in the first place. And then again there was ugly

footage of Israel constructing a concrete barrier in the West Bank, without pointing out that the barrier would – literally – save hundreds of lives.

And it was exactly that staple of nightly news that provided some of the background noise for Ben Froumine's teenage years in Melbourne, Australia.

"It enraged me," says Froumine, twenty-two. "I would come home every day from school and watch the evening news. A lot of the reporting was very biased and anti-Israel, and it would kill me. I was living in a great country like Australia, and the only thing they would get, the only thing the people there would know about Israel was the nonsense they were fed on television and in the newspapers. And seeing all that blatant anti-Israel, biased anti-Zionism just enraged me."

It not only enraged him, but also motivated and encouraged him to do what he says he had wanted to do "ever since I can remember myself" – join the IDF.

"I was so frustrated, so agitated, that I felt I had to do something," says the soft-spoken Froumine, who channeled that frustration into joining one of the IDF's choicest units, an elite unit whose name he won't even utter.

"This was my country, my people. On the one hand you had all these Jews overseas saying, 'Why doesn't Israel do this or that, why don't they just carpet bomb Gaza?' On the other hand you had the left-wing Jews, and I couldn't understand how they could be so anti-Israel at such a fragile and difficult time for Israel. And then there would be all the anti-Israel extremist Jews.

"I'd go to the university in Australia and see horrible anti-Israel posters on the wall, but I was a minority, I couldn't go fight with everyone. But it enraged me, and I wanted to do something about it."

And so he did. Froumine went to Israel, where he was born but left with his parents when he was just a year old, and volunteered for his elite unit.

"I told you about the people who would give Israel advice about an incursion into Gaza? Well, it's not them doing the fighting. It's not their mothers or sons who have to pay the price. I didn't think they had the right to talk. If I wanted the right to talk, I needed to do something about it."

Now, after enduring a grueling fourteen-month training course, one of the most physically challenging and taxing that the army offers, Froumine has – if nothing else – earned the right to talk.

"When you're in high school you go to those motivational speeches at school and hear about the need to get out of your seat and take action when things are important to you. That influenced me, and I wanted to do something."

So Froumine, living in as placid and peaceful a city on the globe as one could imagine, would strap a pack to his back weighted down with sand bags and run an eight-mile route to the beach every day to get himself in shape for possible battle in one of the world's least placid locales.

"I was very motivated," he says, adding that he called trainers in Israel and asked them what he should do to train for the army. Some of them were helpful; others thought he was crazy and had no idea what he wanted.

"All my friends thought I was an idiot, nuts, running around the park with a backpack full of sand," Froumine says. But he was persistent. "I spent most of the year before coming to Israel in training. I would run around Caulfield Park, I would do hundreds of push-ups and sit-ups before I went to sleep."

What kept going through his mind as he ran through the streets of Melbourne was that if he didn't run fast enough, or if he didn't do enough push-ups, he wouldn't get into the unit he wanted. So he pushed himself hard. And it worked. When he finally did go into the army, it was easier for him to deal with what awaited him, both physically and mentally.

❖ ❖ ❖ ❖ ❖

As the son of a sabra father, and a mother who immigrated to Israel when she was in her teens, only to leave the country years later with her husband, Froumine had a very good idea of what he was getting into. He grew up in what he said was an "Israeli home" in Melbourne, and used to take family visits every three years to Israel.

"I was always immersed in Israeli culture – Hebrew, stories from Israel, my parents' experiences. I was always interested in hearing about my father's army stories, seeing his old photo albums and all that." His father started off in the Israeli pilot course, and ended in a unit Froumine says he knows nothing about. His mother also served.

Froumine's folks sent him to a Zionist school, Bialik, and his favorite subjects were always related to Israel: Hebrew, history, the Bible.

"We were not a religious family," he says, "something between secular

Froumine participates in a Jerusalem Day march in Israel as part of a teen delegation from his native Australia.

and traditional. My father is not religious, though his father was, and he once said to me that when he moved to Australia it was important for him to send me to a Jewish school because it was important that I grew up knowing where I came from, my religion, and my heritage.

"Everything in our home always centered on Israel," he says, remembering that his Israeli relatives used to send videos of popular Israeli children's television programs for him to watch. "I was always captivated by Israel."

That he was born in Haifa set Froumine apart from the other kids in his class. While at a certain point in school most of his classmates' interest in Jewish studies, Hebrew, and Israeli history waned, his remained strong. "All the nonsense that they taught actually meant something to me," he says. "It was important to me, I connected to it. For some of the other kids, it was just part of their curriculum. For me it was the essence."

Considering this background, it should not have come as much of a shock to Froumine's parents that their son would want to spend an extended period of time in Israel. So when he decided to spend the "gap year" between high school and college in Israel, they were supportive. But when he wanted to come back again and do the army, that support melted away.

"This is not something they wanted," says Froumine, who with short-cropped black hair, small glasses, and an infrequent smile projects an air of intensity and determination. "You can imagine, your family wants you close to them and sheltered."

Right now he is neither, not close to them nor sheltered, and that very prospect sparked what he calls "the war at home."

During his "gap year in Israel" Froumine took part in a six-month program that included seminars and tours with peers from all over the world. He went to Sinai for a month, volunteered for a while at Magen David Adom in Kfar Saba, and then enrolled in Marva, an eight week program giving participants a taste of Israeli boot camp and army life. Something clicked.

"My dream was always to come and do the army," he says. "This was an easy way to give it a shot, without scaring my parents too much. I did it, and it really gave me a lot of motivation. One of the officers there understood that I was interested in coming back and doing the army, so she helped me do my homework about the different units, and which units I could apply for."

Froumine was very much taken by the whole adventure. "It was a great experience, I was eighteen years old. It was something totally different and exciting. It was difficult in the beginning, getting used to army life, going from being a civilian to a soldier, all the challenges that you come across in basic training. They strip you of your free will. That's a tough transformation, but I got hooked."

His experience there, he says, eased the difficulty a couple of years later when he would enlist in the regular army. He had had a taste, and was prepared. His parents, however, were not.

Froumine honored a promise he made to his parents, that after his year in Israel, and some time traveling in Brazil, he would go back to Australia and begin his studies. He enrolled at the Royal Melbourne Institute of Technology, starting a degree in communications.

"I was in Melbourne, studying, but after a while I just couldn't hold it in any more and applied for a leave of absence to come back here," he says. "My deliberations were whether I should do the army before or after university, and at first I gave in to my parents and started my studies. But after a year, I thought that if I completed my degree and then came to Israel, I might not still want to do the army at that age. So I decided to cut my studies short and enlist."

Froumine says it was not as if he was not enjoying the university life. "But I just couldn't hold myself back anymore. There was something I wanted to do. It was at the edge of my fingertips, within grasp, and despite what I told my parents about coming back to study, I did not want to regret this for the rest of my life. I figured, 'I'm young, it's my life. Why not?'"

Froumine says it was difficult for him to reconnect with Australia and his friends when he returned from his year in Israel.

"I told my father that my head was in Israel, but the rest of me was in Melbourne. I saw that there was something else out there, beyond what was in Australia, beyond the concerns you have in your life in Australia. It didn't concern me at all what I was going to study. It didn't seem relevant, I wanted to come here.

"There is all this social pressure in Australia to finish high school, then go to the university to study, then go live in the suburbs, work, send your kids to a Jewish school. I wasn't in a rush to get into that. I wanted to travel; I wanted to conquer my dreams. I wasn't going to give up on it. So in December 2005 I came back. I did my homework and found Garin Tzabar. I thought about where I would live, who would take care of me as a lone soldier, who would do all the paper work. Garin Tzabar did all that."

And then there were his parents.

"They always knew I dreamt of going into the army, but they never took it seriously, which is why they were quite surprised when I told them of my plans. I had always talked about it, but they thought it was just a childish desire."

When Froumine started talking about the army, some of his friends asked if he had thought about going into the Australian army. "I got those questions a lot: 'Why don't you go to the Australian army if you want to play cowboys and Indians?' I took that as an insult, because it was not that I wanted to play cowboys and Indians. It is Israel we were talking about, not some childish desire."

Not only did Froumine want to serve, but he wanted to serve in one of the country's best units. Here, he admits, the whole macho mystique thing did come into play.

"I always wanted to get into a top unit," he says. "There were a couple of units I would not be able to get into because of my glasses, so I went for the best one I could get in with glasses. Maybe you can say the movies kicked in there. When you're a kid you hear stories about Entebbe, and it motivates you."

One of the benefits of being in a top unit is that it attracts other soldiers equally motivated. And the soldiers in Froumine's unit understand his drive.

"The values important to me are the values important to them, or most of them," he says of those with whom he serves. "At least for the guys in my team. My team is very motivated, a very Zionistic bunch. Some of the guys are there for the action, but for the most part I landed in a unit of Zionists."

But that is not the case across the board. "Other guys I come across in the army will say, 'You sucker, what are you doing here, you're from Australia, why don't you go tour around there? They say they are going to Australia the minute they get out of the army.

"I tell them, 'If you don't want to be here, then go to Australia. I don't need you here. The country doesn't need you here. If it is not good for you here, then go.' I am pretty blunt. I hate hearing, 'You are a sucker.' It drives me crazy. What is that anti-Zionism?"

Another thing Froumine says still drives him crazy, even though he feels an integral part of his team, is the teasing he gets for his Australian-accented Hebrew.

"The language barrier was difficult at first," he says. "I didn't always understand everything. As much as I love the guys, they drive me nuts when they laugh at my accent. I still get it, even today. Its part of the experience, I have to come to terms with it."

Getting used to the ribbing is the very least of what he has had to come to terms with. The excruciating training takes a lot more effort.

"It is a very difficult experience, both physically and mentally," Froumine says of the fourteen-month training course. "You count down the days, the weeks, and the months. There was an older guy with me in my unit who has since been released and gotten married, and one day we were sitting around talking. Someone asked what his most emotional moment was, finishing the course, finishing the army, or getting married? He said finishing the course, by far, much more even than getting married. It's a feeling of euphoria, exhilaration. That you finished, that you survived. Now everything becomes easier, simpler, the good life – freedom."

It is impossible for anyone to say they "like" the course, Froumine says. But, he adds, "You do some amazing things, amazing. It is one of the most elite units in the world in this type of warfare. And I also did the paratroopers' course, which is a great thing to tell friends back in Australia."

Froumine says he feels that finishing the course will give him "all kinds of tools to deal with the challenges and obstacles in life. Compared to what we did, everything else will seem insignificant, small."

Now that he is done with the course, and actually participating in missions, his time is much more his own, the demands far less stringent.

"Now the conditions are great," he says. "We train a lot to keep up our level of professionalism. But we also have a lot of free time. We read books. I have started to learn guitar, I want to learn languages, French and Portuguese."

As a lone soldier who entered the service when he was twenty, Froumine is eligible for release in three months. But he plans to sign on for at least an additional six months.

Froumine in a Palestinian alleyway.

"I'm not ready to leave yet," he says. "It is good for me in the army. This is all I have in Israel. I have no other job, this is my job, and it is interesting. This is my life right now and I enjoy it."

Ironically, when he does make the decision to leave the army, Froumine – who lives with an uncle and his family in Tel Aviv – does not know whether he will eventually live in Israel. The irony is that after going through so much in the army, after extending himself and risking everything, he doesn't know whether the state he trained and went on missions for is the one he eventually wants to settle down in.

"I would love to live here," he says. "I so connect with the country on the one hand. But on the other hand, my family is there, and my family is everything. As much as I feel I've come here to do a good thing, it was to a certain degree a selfish decision. I feel I am serving a greater cause, doing something special and good, but it was still a selfish decision on my part. I left my family to do something *I* wanted to do. I would love to live here. I always say that if I could get my family to live here, it would solve all my problems, but I don't know if that is going to happen."

For the immediate future, unless he meets a girl and gets married in Israel, Froumine plans to return to Australia and finish his studies.

"The first step to becoming Israeli is doing the army, it's a melting pot of Israeli society. I've gone down the right track as someone who wants to make aliya," he says. "But for the meantime I've decided I'm going to go back and be with my family and my thirteen-year-old sister; I want her to have a big brother. I'd love to live here; we'll see what will happen. Right now, I can't decide."

With that, he says he has no regrets about how he has spent his last two years. "When I look at my friends in Australia, I'm not jealous of them, but I do get extremely worried and anxious. On the one hand I'm twenty-two, I'm still young, but in Australia by the time you are twenty-one or twenty-two you already have your first degree; and by time you are twenty-three or twenty-four you might already have a second degree and be earning thousands of dollars a month. You are settling down already, can afford your own car and apartment. And I am only now going to start my studies at twenty-three and twenty-four.

"In Israel, of course, that's no problem," he continues. "Here you can start your life at twenty-seven or later, the army postpones everything. But in Australia it's different. Sure, I'm worried about it, but I also think, 'How many people can achieve their dream at such a young age?' This is something I dreamt about my whole life. Some people only achieve their dreams toward the end of their lives. I've done it already. I guess now I need to find a new dream."

Postscript

Words from a Father

Arthur Stark
Chairman of the Board
Friends of the Israel Defense Forces

I write from aboard a Diaspora-bound jet, in the contrails of which I feel the spirit of my eldest son left behind on the soil of our forefathers. Very much a man at eighteen years of age, Adam, upright and uniformed in the dignified green of the Tzava Hagana L'Yisrael, the Israel Defense Forces, is my own lone soldier. I am not embarrassed to say that my eyes well with pride, concern, longing, and hope; but above all, respect for what he has taken upon himself to do.

This journey began in 2002 with a mission to Israel through the Friends of the Israel Defense Forces. When I decided to take Adam, who was twelve at the time, people said: "Are you crazy? It is the height of the intifada! It is too dangerous!"

My answer was that there is no place safer than with the IDF. I pray that for Adam that statement remains true. From that week of touring military bases all over Israel and meeting brave soldiers who defend the Jewish homeland, sprang a love affair with the IDF for Adam and myself and a life's mission. While Adam embarks on a path of service and personal sacrifice, I am privileged to lead the organization that works to improve the lives of thousands like him, as national chairman of Friends of the Israel Defense Forces.

As the son of Holocaust survivors, I grew up with the words "Never Again." However, this phrase bears little meaning unless we are willing and able to back it up. The world's sole Jewish army alone can be relied upon to do that. And it is more than a conventional army. Highly skilled and extraordinarily principled, it is a fountain of values, which teaches life skills that no university can rival. Just as the Jewish people have produced great scientists and thinkers and doctors and educators, so too has the IDF, conveying its achievements into civilian innovation and advances. Our enemies have also caused us to evolve into a species of great warriors as a matter of survival. By land, by air, by sea, by space, and in intelligence; and by ingenuity and resourcefulness.

But why my son, or your son? Why did my wife and I accept it? How many sleepless nights must we incur?

But these questions beg one other:

If not our children, sons, then who? My son the doctor or the lawyer or the businessman? Maybe someday. But for now, the world we live in, particularly as Jews, is no safer in the missing shadows of Wall Street or the subways of London or a beach in Bali.

We all want to protect our children. I rationalize to myself that through his IDF training, Adam will learn how to protect himself and someday, God willing, his own family. He is more articulate in his actions than in his words, but he seems to understand and accept the dangers

and the sacrifices, and demonstrates both a thrill for the personal challenges and a commitment to a larger purpose.

I hope I read him right, but I also realize that he has made his own choice. I have felt responsible for this choice, for exposing him to this way, for surrounding him and our family for the last six years with fellow zealots of the FIDF who share our passion for Israel and the insatiable need to provide support for the wellbeing of its young guardians. But I understand now that this line of thought only deprives Adam of the credit he deserves for his chosen path, one which his own three siblings may not likely follow. The dozens of lone soldiers whom I've met each have their own motivation, their own varied upbringings, and each are resolute in their affirmations that their IDF experience is an irreplaceable part of their lives and their souls.

In the few days I have just spent with Adam, I saw an extraordinary young man, resembling the boy I've loved for eighteen years, but remarkably changed. The determination and motivation he displayed were the same as he had always shown for sports; only now the stakes have become far higher as he pursues the most difficult duty he can qualify for.

Meanwhile, we plan our future visits, await phone calls, and stare at the screensaver of Adam on our computers. We pray for his safety until we can see him again, knowing that the Jewish people the world over are safer thanks to all those who, like him, pursue this courageous option in the paradoxical state that exists between self-determination and destiny.

They deserve our utmost respect and gratitude.

November 2008

Words from a Supporter

Heather Reisman
Founder of HESEG

Our getting connected with lone soldiers happened quite serendipitously.

A few years ago my husband and I were taking a walk with Matan Caspi, a young Israeli who had recently completed his military service. We expressed to Matan our interest in finding a good project to support in Israel. He quickly began to talk with us about how great it would be if someone found a way to do something for "lone soldiers." Lone soldiers, he said, are a very special group of people who receive little recognition or support for their incredible contribution to Israel.

He went on to explain that these young people often have a very hard time upon completing their military service because it is then that they really feel the challenge of living in a place with no family or true support system. After giving so much to the country, many are unable to afford university and some end up having to return to their homeland for lack of financial resources.

"Wouldn't it be great," Matan ventured, "if you could somehow help some of these young people."

The idea immediately caught our imaginations. The result of that short discussion eventually led to the creation of HESEG.

HESEG, which means achievement, has as its core objective the provision of full university scholarships and living expenses to lone soldiers who have distinguished themselves during their time in the military.

Each year a selection committee, made up of leading Israelis all of whom have themselves made great contributions to the country over decades, reviews hundreds of applications. From these applications the committee selects the top 150 to become HESEG scholars.

In addition to attending university, each scholar commits to doing weekly volunteer work in his or her community and also participates, through HESEG, in special projects during times of stress or war in the country. The HESEG community – scholars and staff alike – merge into a kind of extended family providing for each other some of the "glue" that is normally provided by having a mother and father, sisters and brothers, living in the country.

As the founders of HESEG, and having now had several years to really get to know these proud, intelligent, and passionate young adults, we feel hugely blessed to be part of this initiative. Each lone soldier has an incredible story to tell. More important, each has so much to give to a country whose very survival depends on building a society of people with extraordinary heart, mind, and soul.